The Curious Artist

DRAWING TREES AND LEAVES

JULIA KUO
MICHAEL WOJTECH

QUARRY

Quarry Books titles are also available at discount for retail, wholesale, promotional, and bulk purchase. For details, contact the Special Sales Manager by email at specialsales@quarto.com or by mail at The Quarto Group, Attn: Special Sales Manager, 100 Cummings Center, Suite 265-D, Beverly, MA 01915, USA.

ISBN: 978-1-63159-260-7

Library of Congress Cataloging-in-Publication Data available.

Cover Illustration: Julia Kuo
Design: Phyllis Sa

Printed in USA

8 PREFACE

10 INTRODUCTION
NATURE SKETCHING BASICS

FORM AND FUNCTION
14 HOW TREES EVOLVED
16 A TREE'S LIFE STAGES
18 PHOTOSYNTHESIS
20 SEEDS
32 ROOTS
38 WOOD
46 BARK
56 LEAVES
68 FLOWERS AND FRUIT

TREES IN THE WILD
86 IDENTIFYING TREES
98 TREES AND OTHER ORGANISMS
106 THE WORLD'S OLDEST TREES
110 FAMOUS FORESTS

LIVING WITH TREES
123 THE BENEFITS OF TREES
126 PLANTING TREES
132 TREES IN ART AND CULTURE

140 RESOURCES
142 ACKNOWLEDGMENTS
143 ABOUT THE AUTHORS
144 INDEX

PREFACE

I travel often, and I take my sketchbook everywhere I go. I grew up in hot and dry Los Angeles, my current home base is windy Chicago, I spend my winters in tropical Taipei, and I'm currently teaching a semester at Washington University in St. Louis. I'm also on a quest to see as many national parks as possible. Just this past year, I've visited Zion, Denali, and Acadia—all gorgeous parks in such different ways.

As a result of all this travel, I often find myself drawing different natural environments. The chaparral of Southern California is an olive yellow-green color, which contrasts to the saturated green of Taiwan's tropical rainforests, whereas the red and gold foliage that blankets Acadia National Park in the fall is completely different from the others.

And yet I can't help but make connections: magnolia trees seem to be in many parts of the United States, but the flowers and leaves look a little different from place to place. Showy flowers that I've seen only in botanical gardens or conservatories in the United States grow with ease in a Taipei city park. It makes me wonder: What's the secret system? Why here and not there? Why do these plants have this shape, and why do those flowers come only in that color?

Drawing and understanding seem to go hand in hand. We might agree that an avocado fruit can only be called an avocado if the pit is round, the peel is hard, bumpy, and green-black, and the meat is soft, creamy, and yellow-green (unless you've left it on your counter for too long!). As an illustrator, these important nuggets of information direct my drawing. I'll want to show the bumps on the peel and make

the pit enough of a circle to show that it's round. Aside from making a lovely drawing, I am also giving you visual clues to understanding what we're seeing in nature and why. Drawing nature's effortlessly beautiful shapes and forms feels like an extension of the admiration I feel. I can actively marvel at the curving leaves on a maple branch by studying it and knowing it well enough to put it on paper.

Drawing through observation is a natural first step, but learning more about the subject—past what is visible—always makes the drawing process better. I am so grateful that I have been able to lean on the expertise of science writer Michael Wojtech. It's his understanding of trees and leaves that has made my illustrations complete. While it is important that this book be filled with drawings of trees, it is even more important that the book impart real information about trees. I have certainly learned a lot through this process. Drawing what I have learned from Michael's writing has become a test of my understanding; have I learned thoroughly enough to accurately translate his ideas from words to pictures?

Working on this book with Michael has uncovered many little secrets that I wouldn't have noticed otherwise. If you were to walk with me from my apartment in St. Louis to nearby Forest Park, you would first see a magnolia, followed by two varieties of dogwood, a redbud tree, and then a row of flowering trees. I wasn't sure what type of flowering trees these were at first, but the telltale bark told me they were Japanese cherry trees. Next to the cherries are two large trees just putting out the tiniest leaves, but the shapes of the leaves are dead giveaways for oak and maple!

The goal with this book is for you to understand why trees behave and grow the way they do, and to get you jump-started on drawing these forms. Take your time and try some of the drawing activities in this book—there are quite a few to choose from. Better yet, look outside your window and draw what you see! How does the tree closest to you look in the different seasons, and how can you show that on paper? Most important, have fun!

INTRODUCTION:
NATURE SKETCHING BASICS

The possibilities for drawing trees might seem endless. There are so many types of trees in the world, and so many variations of each type of tree—not to mention how each tree's appearance changes in different seasons or stages of life. If you think back to the tree you grew up climbing, or the trees you notice blooming in the spring or changing colors in the fall, you might have a good clue as to where you would like to start drawing.

The drawing activities in this book cover many different topics, from leaf shapes to flowers around the world to bonsai tree styles. Each activity page will show you several examples of that topic, as well as a short step-by-step tutorial to drawing one of those examples. You can start with the drawing tutorials to get familiar with building images out of basic shapes. Try using a tool that you're comfortable with—maybe a pencil, pen, or colored pencil—and don't be afraid to draw the same example more than once!

Once you're comfortable with tackling a more complex image on your own, go back to your favorite activity pages and pick out other images that you'd like to try drawing. You can also start to explore different materials and tools. What if you drew on top of cardboard instead of paper, or if you used wet media such as watercolor or gouache? When was the last time you cut out shapes from a magazine?

Experimenting is a regular part of an artist's process. Trying different materials and tools will tell you bit by bit about what you work best with. Keep little notes about what worked for you and what didn't. You might be surprised to discover which medium captures the right look in your drawings—but the only way to tell is to try!

Lastly, don't forget to go outside. The best sources of inspiration are all around you. Find something convenient to take with you, such as a sketchbook or a small easel. You might find that drawing from an illustration is very different than drawing from a tree in real life, but you can tackle your subjects in the same manner as the tutorials. Start with basic shapes and slowly add on detail. Use a tool you're familiar with at first, but gradually let yourself branch out—just like a tree!

HOW TREES EVOLVED

The first plants to colonize land hundreds of millions of years ago required water to avoid drying out and lacked the structure to support themselves against gravity. The development of vascular systems brought the ability to transport water, nutrients, and food over longer distances and for the structure to grow more upright, allowing terrestrial plants to rapidly diversify and spread. As further refinements evolved, some plant species grew taller and gained a distinct advantage in the competition for sunlight. We define them today as trees—plants with self-supporting, perennial, woody stems.

Tall tree ferns in early forests would have been recognizable, but horsetails up to 30 ft (9 m)-tall and club mosses reaching 130 ft (40 m) dwarfed their relatives found today. In time, gymnosperms refined seed production and came to dominate forests. Seeds have a strong, protective coating and contain food stores that allow them to remain dormant and germinate when conditions are favorable.

Angiosperms gained the competitive advantage with seeds that are protected by ovary walls, which develop into fruits. Angiosperms dominate many of today's forests, while gymnosperms, such as pine and spruce, are most prevalent at higher latitudes, where they are better adapted to less hospitable growing conditions.

CURIOUS ARTIST TIP

These prehistoric plants all look very different. When drawing a plant, think about what makes it unique and identifiable. Is it the overall shape, the way the leaves grow, or the showy flower petals?

BRYOPHYTES, TRACHEOPHYTES, ANGIOSPERMS, AND GYMNOSPERMS

The oldest and most primitive plants, bryophytes include mosses, liverworts, hornworts, and horsetails. The next evolutionary step saw the development of tracheophytes, or vascular plants, which include ferns.

These plant categories were eventually dominated by seed-bearing plants—angiosperms and gymnosperms. Angiosperms are flowering plants whose seeds are enclosed within a fruit. By contrast, the seeds of gymnosperms are exposed and most often develop on the surface of scales or leaflike structures that form cones.

Angiosperms are flowering trees such as magnolia, oak, and dogwood. All conifers are gymnosperms, as are cycads and ginkgo.

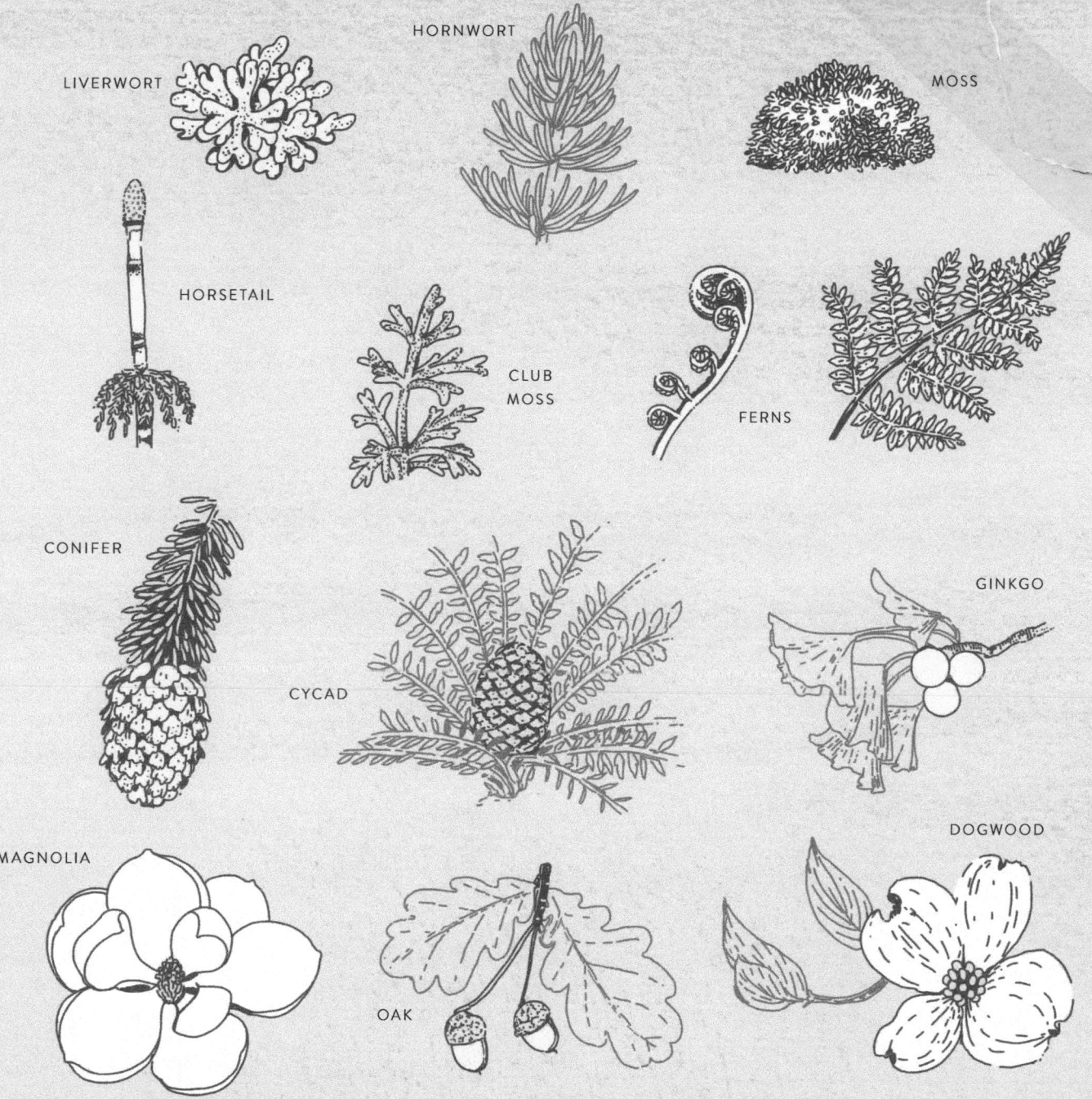

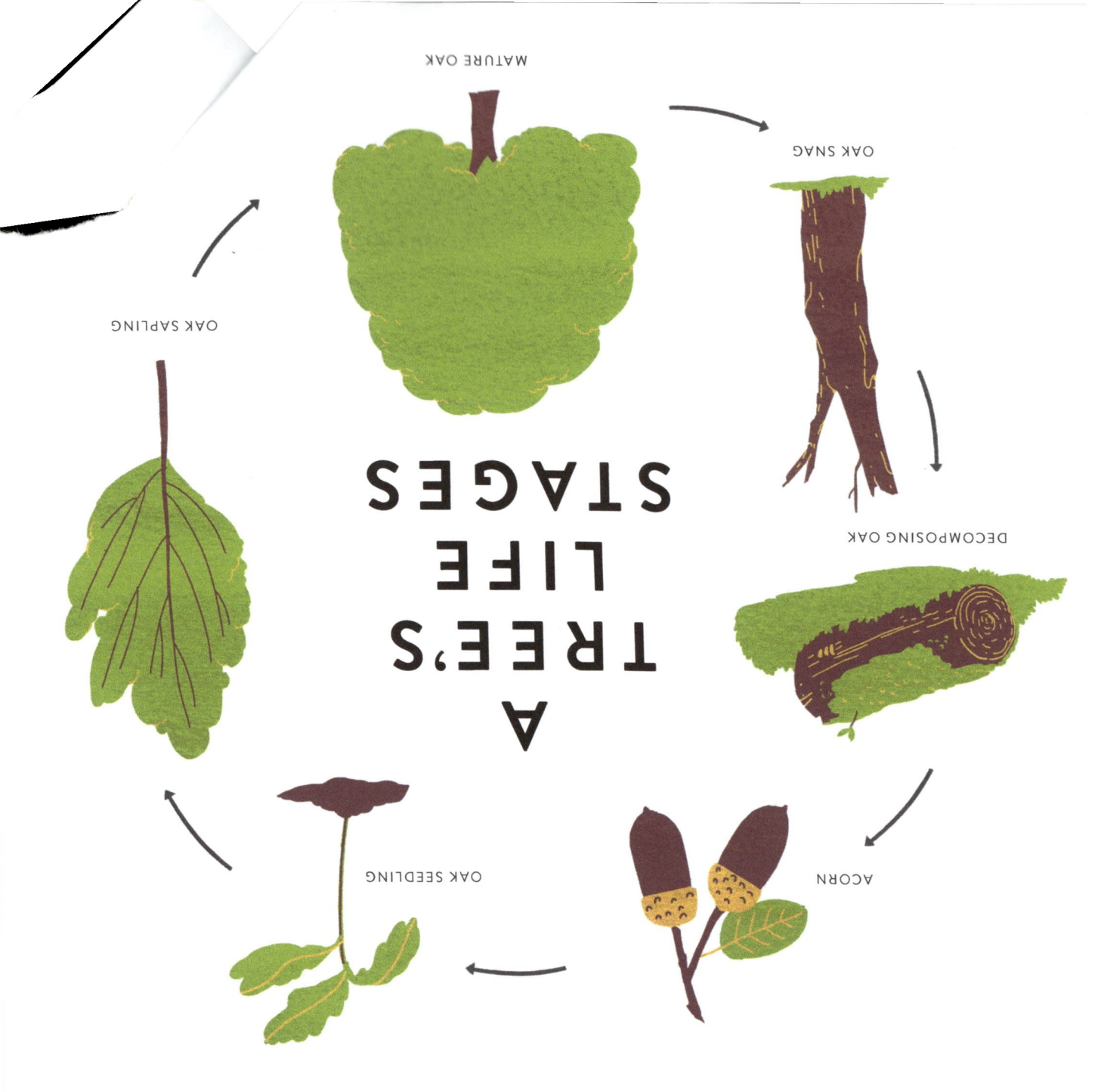

Once a tree sprout exhausts the food reserves in the seed, it makes its own food through photosynthesis—most of which occurs in the leaves—to fuel its own growth. The tree literally builds itself.

Beginning as a seedling, a tree must grow to outcompete with surrounding trees and other plants. As a sapling, its slender trunk grows thicker and upward. Branches extend outward to expose an increasing number of leaves to sunlight, which powers the production of food needed to expand the tree's supporting framework. Roots must keep pace to supply adequate water and minerals and to anchor the tree.

Healthy, mature trees continue this growth but also devote energy to produce seeds, which pass on the tree's genetic lineage and help perpetuate the species. Over time, a tree's decline can be spurred by factors such as injury, disease, extended drought, and old age, which lead to decreased growth rates and eventual death.

Standing dead trees, referred to as snags, and fallen trees provide important habitat and food for numerous organisms. They decompose over time and return nutrients to the soil, bringing fertility for a new generation of trees and for many other organisms, as well.

CURIOUS ARTIST TIP

Consider how much detail the subject of your drawing needs. Does it help that an acorn's cap has little bumps or that its end is pointy? How many details could you leave out and still recognize it as an acorn?

PHOTOSYNTHESIS

The energy utilized by just about all organisms on Earth ultimately comes from photosynthesis, the process used by plants, algae, and some bacteria to produce their own food. Trees play a big role in this giant food web. The fungi that feed on and help decompose a dead trunk, the caterpillar munching a leaf, the deer nipping buds, and the wolf (or human) eating the deer all rely, directly or indirectly, on the energy of trees and other photosynthetic organisms for survival.

This energy starts with sunlight, which is captured by chlorophyll in a tree's leaves (and, to a much lesser extent, its bark, buds, flowers, fruit, and other components) and used to convert carbon dioxide and water absorbed by the roots into sugars, or carbohydrates. Through this process carbon is removed from the atmosphere and oxygen is released.

These carbohydrates fuel growth and maintenance in the tree and are also combined with minerals to produce important compounds such as protective waxes on leaves, enzymes that direct a tree's life processes, and defensive substances such as tannins and latex. These are the same sugars that sweeten the sap of maple, birch, and other species; the sap is tapped in spring and boiled down into syrup. Sap also provides food for squirrels, birds, insects, fungi, and many others.

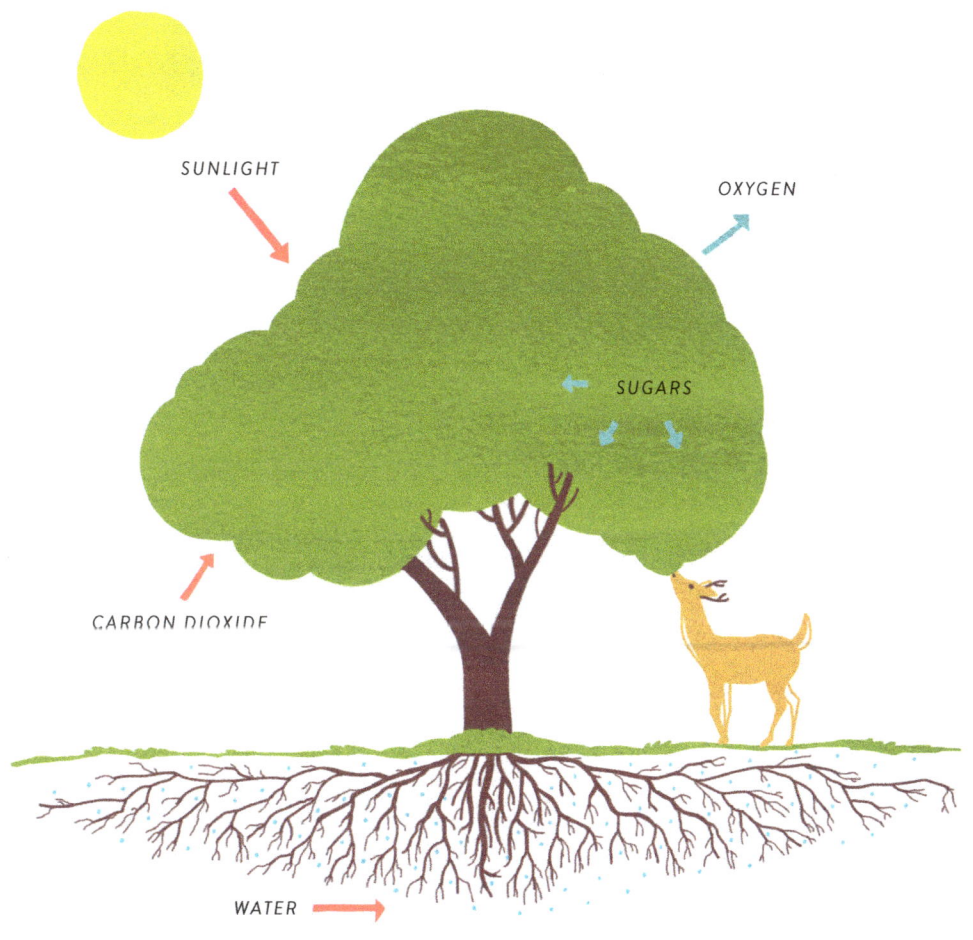

SEEDS

SEED COAT

PLUMULE:
GROWS INTO SHOOT

HYPOCOTYL:
GROWS INTO STEM

EMBRYO

RADICAL:
GROWS INTO ROOT

SEED

GERMINATION

Trees produce seeds that are prepared to flourish—they have an outer coating that protects an embryo, complete with a miniature root and shoot, and contain a food supply to keep the embryo alive and fuel initial growth. Yet there are strong odds against survival for any individual seed. Those that are not subject to disease or consumed and digested by a host of birds and other animals still require a number of favorable conditions, including adequate levels of water, warmth, and light, that are specific to each species.

The seeds of most tropical tree species, and a few others, can germinate as soon as they encounter a suitable environment. In temperate regions, most species produce seeds in autumn that need to experience a period of dormancy to ensure they don't germinate right away, or during a winter thaw, and then die in the ensuing winter conditions. Dormancy is typically broken after an accumulated period of cold or by the sustained heat of spring.

For some species, a longer dormant period is required. Embryos within the seeds of ash trees are often not fully developed when seeds fall from the tree; a small percentage can germinate that first spring, after a period of winter chilling, but most will remain dormant for another year while the embryo matures.

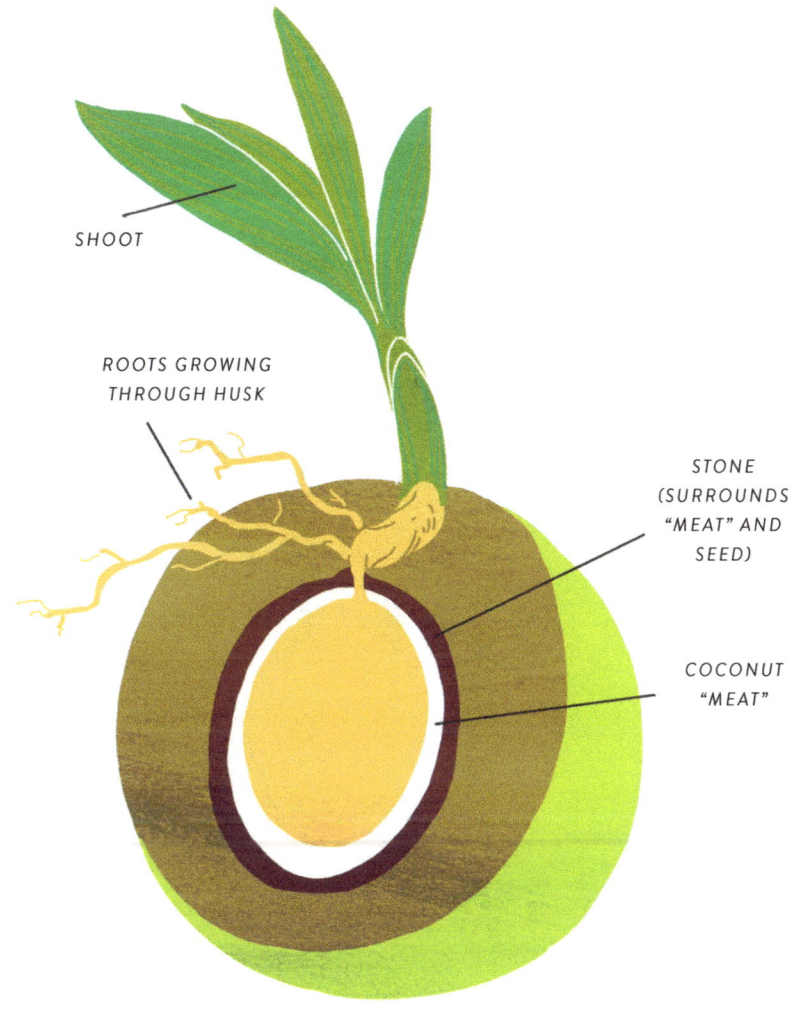

GERMINATED COCONUT

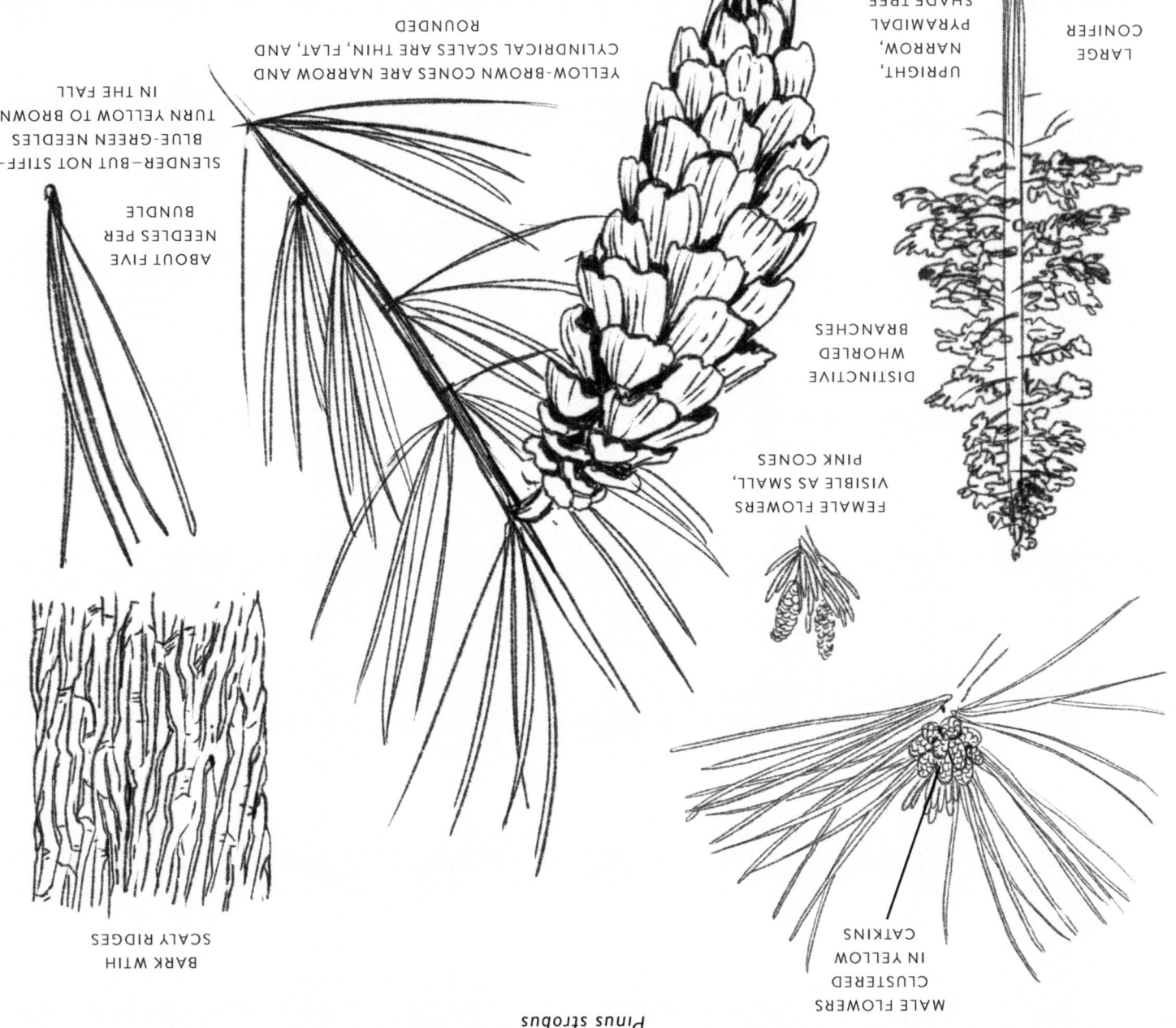

HOW TO DRAW
EASTERN WHITE PINE CONES
Pinus strobus

1. START BY DRAWING A SHORT PEPPER SHAPE FOR THE CONE. ALSO PRACTICE DRAWING SOME WAVY SCALES.

2. DRAW FOUR VERTICAL AND EIGHT OR NINE HORIZONTAL LINES THROUGH THE CONE.

3. MAKE A LITTLE MARK WHERE THE HORIZONTAL LINE TOUCHES THE EDGE.

4. DRAW DIAGONAL LINES COMING OUT FROM THOSE MARKS.

5. OUTLINE SIDE-BY-SIDE BOXES TWO AT A TIME, ALTERNATING LIKE ROOF TILES. USE THE DIAGONAL LINES AS GUIDES FOR BOXES THAT ARE ON THE SIDE.

6. USE THOSE BOXES AS GUIDES TO DRAW THE WAVY SCALES.

7. EACH SCALE HAS SOME RIDGES, SO DRAW TWO OR THREE LINES ON EACH SCALE, SOME SHORT AND SOME LONG.

8. EACH SCALE STARTS HIDDEN BEHIND A SCALE ABOVE IT. DRAW IN SOME SHADOW AT THE TOP OF EACH SCALE.

9. ERASE YOUR PENCIL LINES AND COLOR THE PINE CONE BROWN.

DRAWING TREES AND LEAVES | 23 | FORM AND FUNCTION

SEEDS

EUCALYPTUS
SEED CAPSULES

SEED SURVIVAL AND WIND

Seeds are dispersed from their parent tree in
a number of ways, increasing their chances of
encountering favorable conditions and spreading
the range of the species. These distribution methods
are hardly systematic and most often end in failure.
On average, only one out of each thousand acorns
becomes a seedling, and for other species, such as
birch, the success rate is even lower. The tiny birch
seeds must land on exposed soil, because they don't
contain adequate food reserves to fuel growth up
through the litter of leaves and organic material on
the forest floor to reach sunlight. Trees, however,
have economies of scale on their side—a single oak
might produce five million acorns over its lifetime,
while a birch can total hundreds of millions.

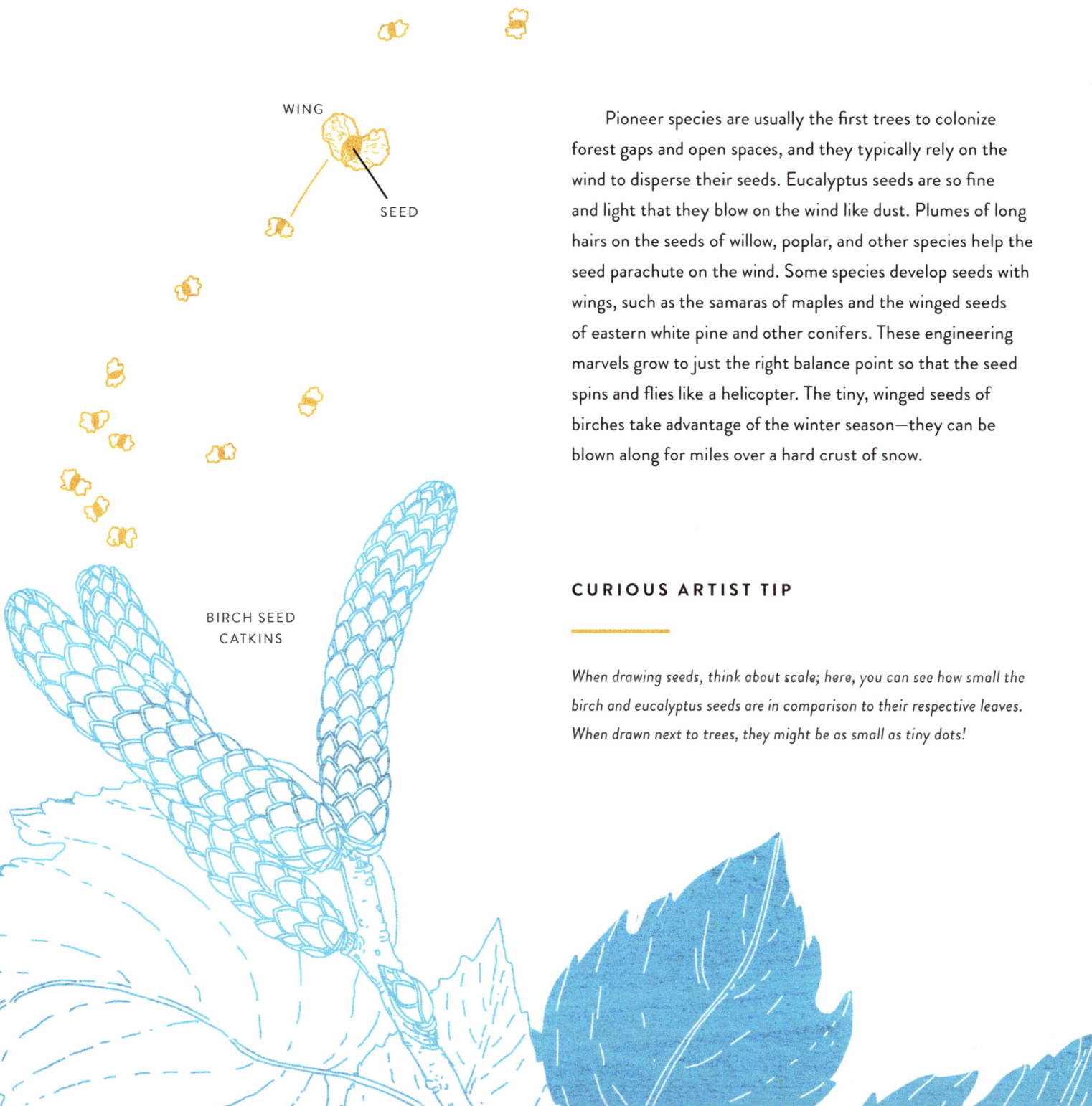

WING
SEED

BIRCH SEED CATKINS

Pioneer species are usually the first trees to colonize forest gaps and open spaces, and they typically rely on the wind to disperse their seeds. Eucalyptus seeds are so fine and light that they blow on the wind like dust. Plumes of long hairs on the seeds of willow, poplar, and other species help the seed parachute on the wind. Some species develop seeds with wings, such as the samaras of maples and the winged seeds of eastern white pine and other conifers. These engineering marvels grow to just the right balance point so that the seed spins and flies like a helicopter. The tiny, winged seeds of birches take advantage of the winter season—they can be blown along for miles over a hard crust of snow.

CURIOUS ARTIST TIP

When drawing seeds, think about scale; here, you can see how small the birch and eucalyptus seeds are in comparison to their respective leaves. When drawn next to trees, they might be as small as tiny dots!

ANIMALS AND WATER

Tree species that grow within intact forests, where winds are less dependable, often rely on animals to distribute their seeds. The fruits that contain seeds often attract these dispersers. As fruit is consumed, its seeds may be discarded or regurgitated, or they may pass through the animal's digestive tract and emerge intact in the animal's droppings, which provide an extra boost of fertilizer and moisture. This passage can help the seeds of some species, such as holly, germinate better by weakening their protective seed coat. Yew and juniper seeds can germinate right away after passing through the gut of a bird; otherwise, it may take a year or two for their seed coat to rot away before they sprout.

In addition to fruits, many animals rely on tree seeds themselves as a nutrition source. As fruits and seeds are collected for future consumption, some are inadvertently scattered or lost, and might encounter the right conditions for germination. Acorns that gray squirrels bury, but fail to retrieve, are conveniently planted and ready to germinate when conditions are favorable. Birds can transport seeds over long distances to assemble their cache.

The seeds of many trees can survive long periods in water, which can distribute them over wide areas. For many tree species in the Amazon, seed production coincides with annual flooding. Perhaps the best-known example of water dispersion involves coconuts, which can travel across oceans before germinating.

CURIOUS ARTIST TIP

All birds have distinctive features that you can keep in mind when drawing them. For example, some birds have a pointed crest on the crowns of their heads, while other crowns are smooth and rounded.

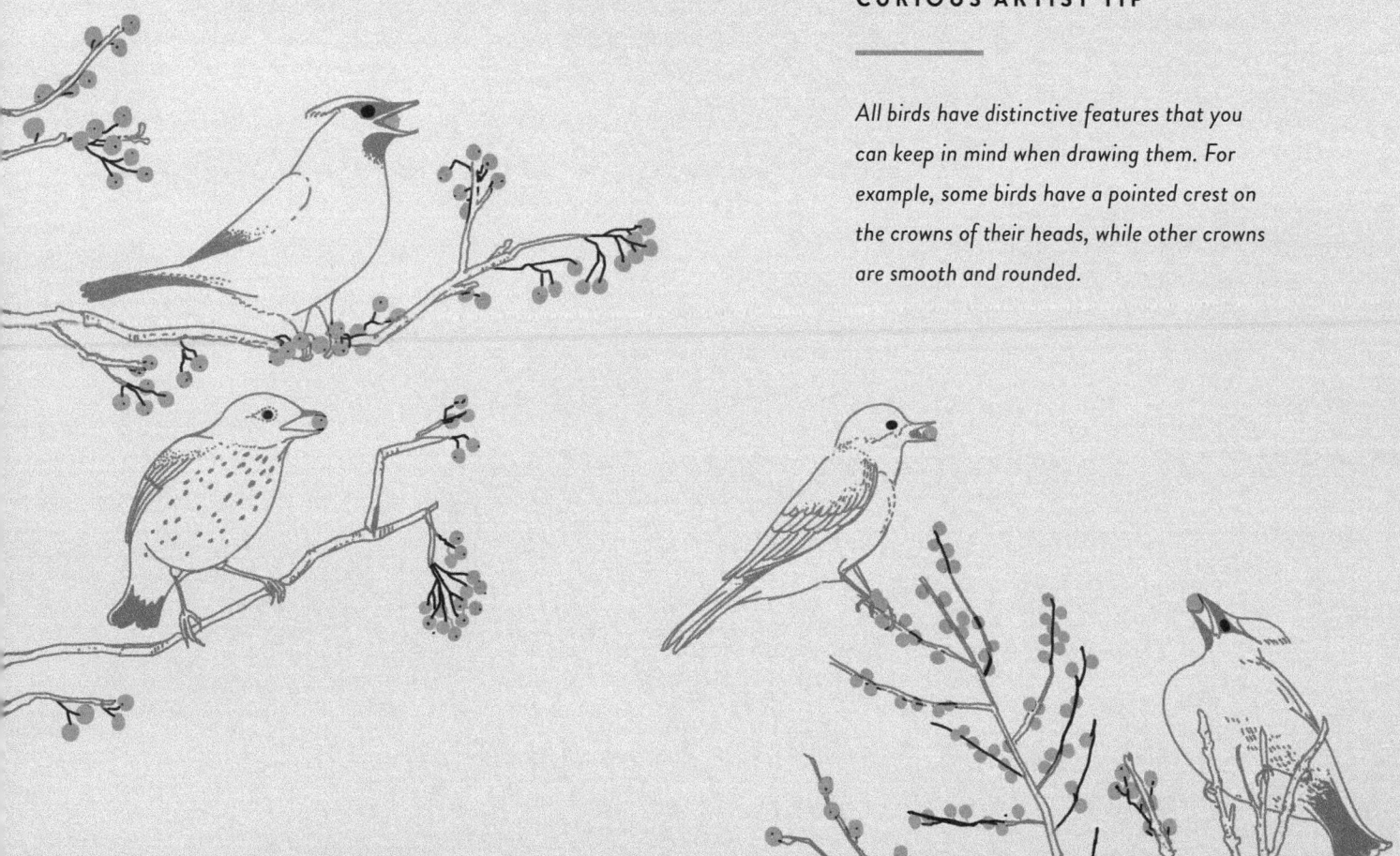

ACORN-EATING ANIMALS

OAK ACORNS

WHITE-TAILED DEER DEPEND HEAVILY ON ACORNS FOR THEIR DIET IN LATE FALL AND EARLY WINTER.

GRAY SQUIRRELS EAT THE ACORNS OF MORE THAN TWENTY TYPES OF OAKS. THEY SPEND THE SUMMER BURYING ACORNS AND MANY OTHER TYPES OF NUTS. THEY EVEN PRETEND TO BURY FAKE ACORNS TO THROW OFF ANY OTHER ANIMALS THAT MAY BE WATCHING.

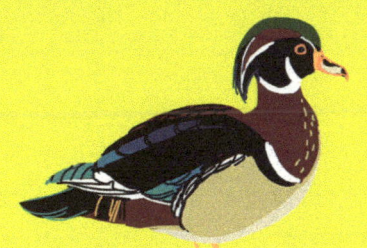

WOOD DUCKS HAVE A WIDE DIET, BUT THEY EAT ACORNS WHEN AQUATIC FOODS ARE UNAVAILABLE OR WHEN PREPARING FOR THE WINTER MONTHS.

THE QUAIL DIET IS LARGELY MADE UP OF SEEDS AND LEAVES. QUAIL ARE ADAPTABLE IN REGARD TO PLANT DIET, SO THEY WILL EAT ACORNS DURING A GOOD ACORN CROP AND LEAFY GREENS DURING SUMMER MONTHS.

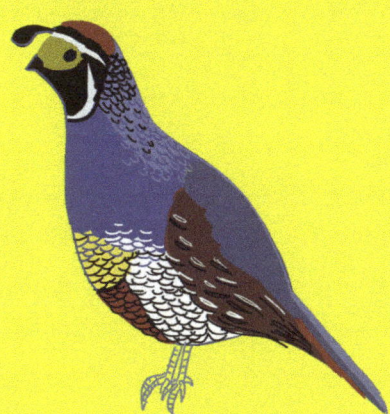

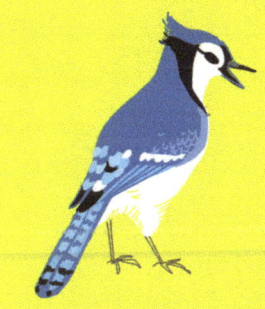

BLUE JAYS ARE UNASSUMING AIDES IN FOREST GROWTH; THEY OFTEN STORE ACORNS IN THE GROUND BUT FORGET TO RETRIEVE THEM.

THE RACCOON IS AN OMNIVORE; ITS DIET CONSISTS OF FISH, AMPHIBIANS, EGGS, INSECTS, ACORNS, AND WALNUTS. FRUITS AND NUTS ARE PREFERRED LATER IN THE YEAR AS THE RACCOON PREPARES FOR WINTER.

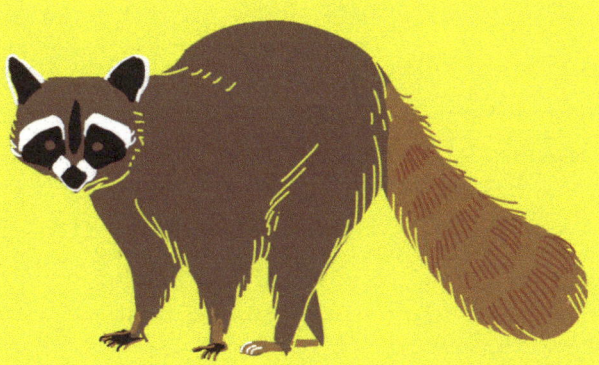

HOW TO DRAW
WHITE-TAILED DEER
Odocoileus virginianus

1. START BY SIMPLIFYING THE DEER INTO THESE BASIC SHAPES.

2. OBSERVE THE HEAD AND ADD DETAILS.

FLAT NOSE

SLIGHT CURVE

LEAF-SHAPED EARS

BOTH SIDES OF THE NECK ARCH BACK

3. OBSERVE THE BODY AND ADD DETAILS.

BACK CURVES DOWN, THEN OUT

CHEST SLOPES IN GRADUALLY

BELLY CURVES LIKE A SIDEWAYS S

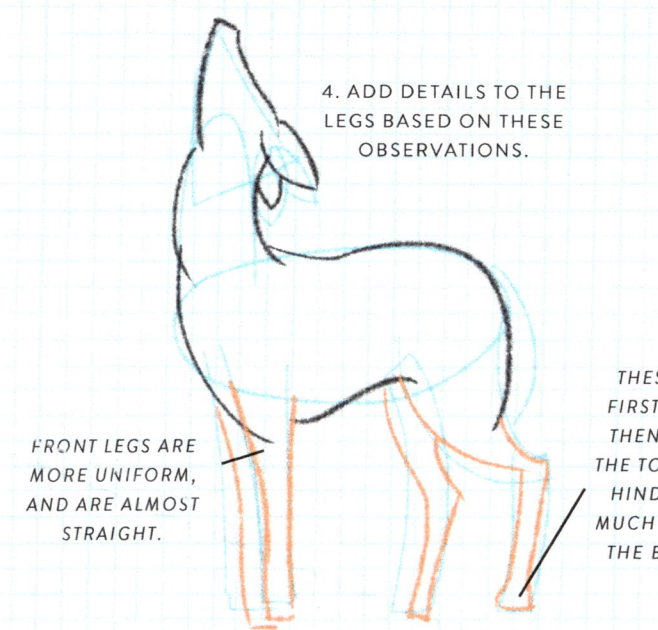

4. ADD DETAILS TO THE LEGS BASED ON THESE OBSERVATIONS.

FRONT LEGS ARE MORE UNIFORM, AND ARE ALMOST STRAIGHT.

THESE HIND LEGS FIRST CURVE BACK, THEN DOWNWARD. THE TOP HALF OF THE HINDQUARTERS IS MUCH THICKER THAN THE BOTTOM HALF.

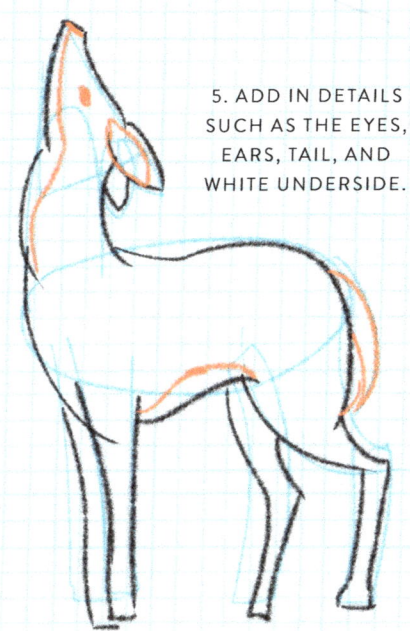

5. ADD IN DETAILS SUCH AS THE EYES, EARS, TAIL, AND WHITE UNDERSIDE.

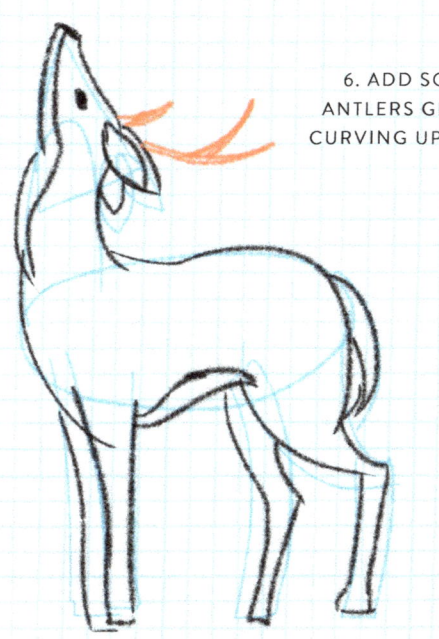

6. ADD SOME ANTLERS GENTLY CURVING UPWARD.

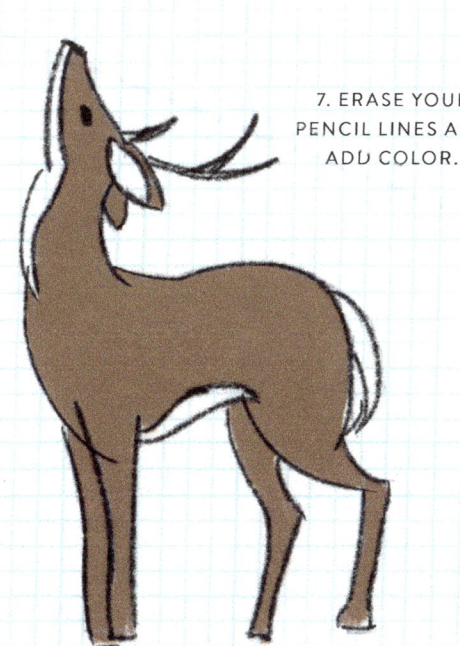

7. ERASE YOUR PENCIL LINES AND ADD COLOR.

DRAWING TREES AND LEAVES | 31 | FORM AND FUNCTION

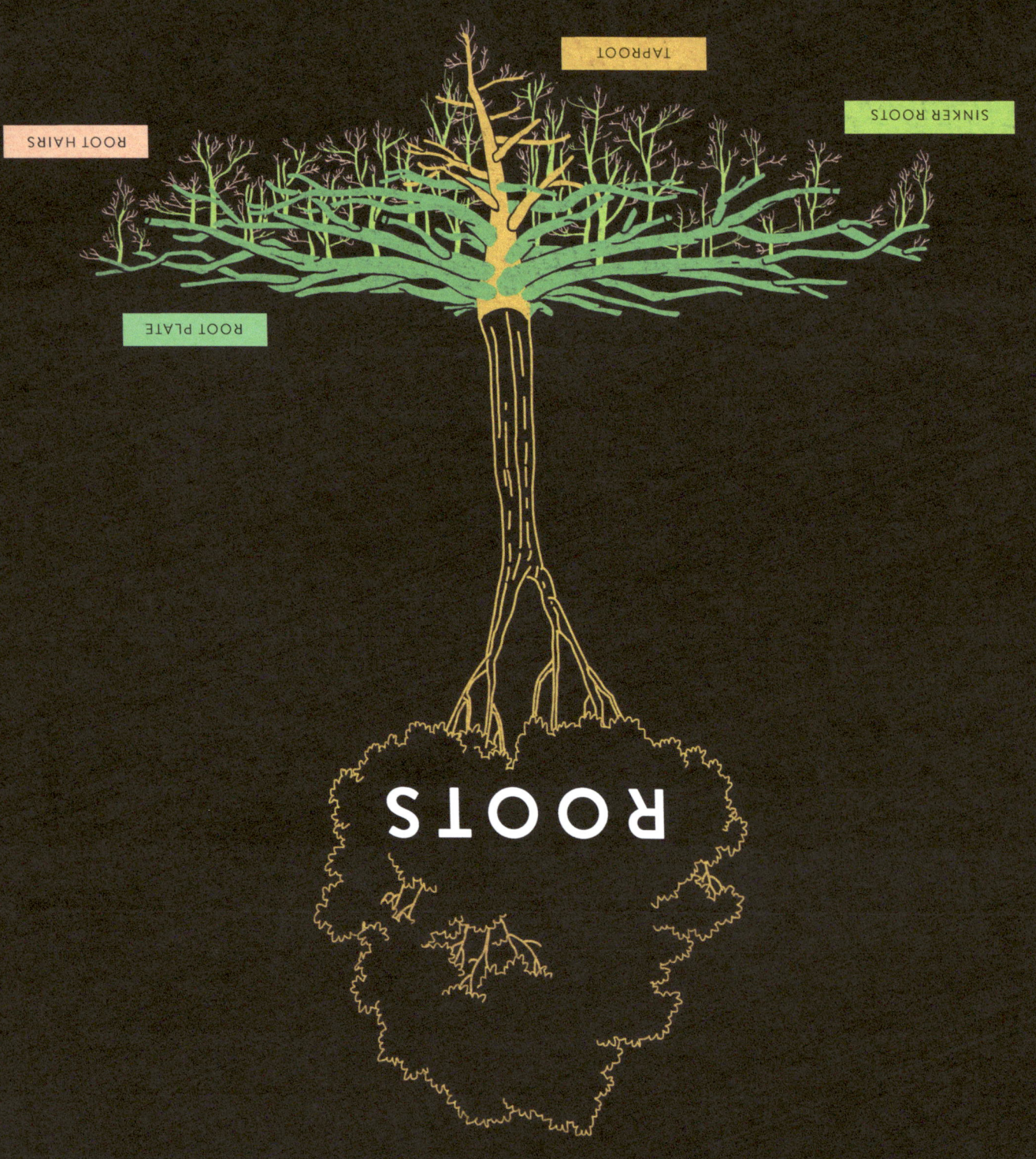

THE ROOT PLATE

A mature tree's roots system is often imagined and illustrated as an underground, almost mirrorlike image of the canopy above it. If you take away the trunk, the mass of a tree's canopy is roughly proportional to that of its root system, but the roots typically grow in a shallower, less patterned profile and often extend well beyond the width of the canopy.

Young tree seedlings start out with a single taproot, which in most cases becomes less important as the tree grows. Over time, new roots grow laterally from the taproot like the spokes of a wheel. This lateral framework of roots branch, fork, overlap, and may fuse together, creating a solid, stable root plate as wide or slightly larger than the canopy, anchoring the tree. Sinker roots, which can be as long and thick as the taproot, grow downward from the root plate and then extend horizontally or repeatedly branch into a fine, bushy end. They gain access to deeper water and provide additional support.

When a mature tree is toppled by wind or some other disturbance, its root plate, if still connected to the now horizontal trunk, "tips up" and extends vertically from the ground. The root plate can easily be mistaken for the entire root system, because most of the small roots, and the fine roots that grow from them, have broken off and remain in the soil.

CURIOUS ARTIST TIP

Most people often assume that a tree's root system is the same shape as a tree canopy, just mirrored under the ground. Root systems actually extend far past the tree canopy, but are not typically too deep.

THE OUTER ROOTS

Numerous small roots, ¾ to 2 in (2 to 5 cm) in diameter, grow from the root plate; they fill the gaps between the larger, lateral roots and grow out over considerable distances from the trunk—up to four times further than the tree's canopy—to reach water, which is not evenly distributed through the soil. These small roots can account for half of the surface area of the root system.

Fine roots grow outward and upward from the small roots, branching multiple times and ending in fans of short fibers that are narrower than the head of a pin. These fibers often have root hairs that increase their surface area. Most of the absorption of water and dissolved minerals occurs in the fine roots, which account for most of the root length. They often go unnoticed because they break off so easily from the larger roots they grow from.

Both small and fine roots of trees repeatedly fork as they grow, often following old root channels, insect tunnels, and cracks, and diverting around rocks and other obstacles. The fine roots are most often found near the soil surface and within the leaf litter, where rainwater and important minerals such as nitrogen and phosphorous, which are released by decomposing organic matter, are concentrated.

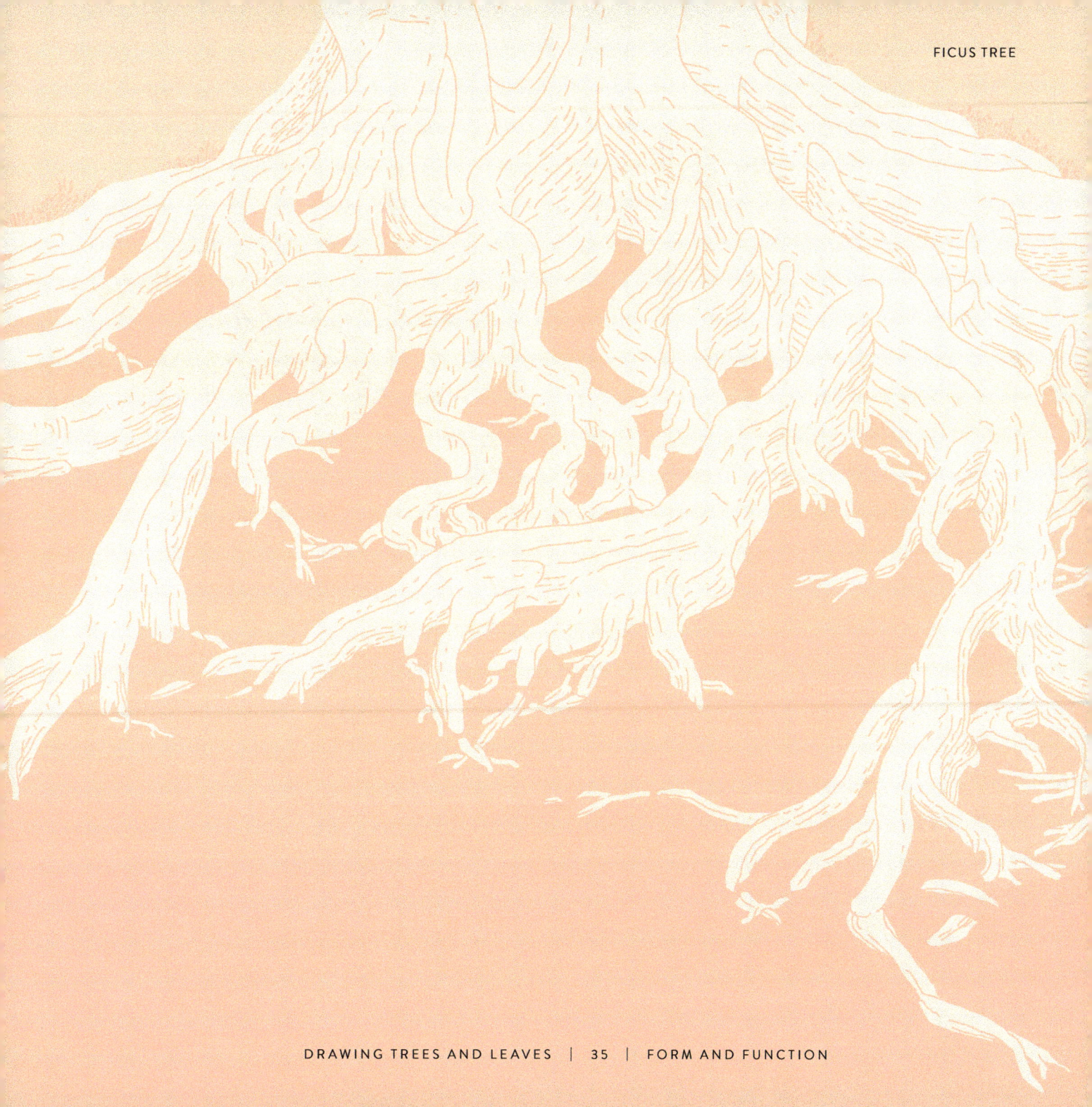

GROWTH PATTERNS

Root growth is more irregular than that of the canopy, where branching patterns of some trees can be specific enough to allow for species identification. Outside of appearances, there is a functional, proportional balance between the roots and the canopy—if the roots are too small, there will not be adequate water for the leaves. If there are too few leaves to produce food, the roots will not have energy to grow. Bonsai trees, for example, are kept from reaching their normal size by restricting their root growth and water supply.

Roots growing in soils with large amounts of organic matter, which holds water and minerals, are more compact than those found in dry soils, where the roots must cover more ground in order to reach adequate water. The depth and width of root systems are limited by soils that are difficult to penetrate and by obstructions such as rock, low oxygen concentrations in the soil, and ground water (which deprives roots of oxygen).

Some species can adapt to local conditions. Willows typically have fine, fibrous roots that help them grow in shallow and waterlogged soils, but in dry soils where water is more widespread they can develop larger, deeper root systems. Other species, such as sycamore, depend on deeper roots and could not survive in shallow soil.

Because roots function invisibly, under the surface, drawing them is a nice way to demonstrate their diverse, functional structure.

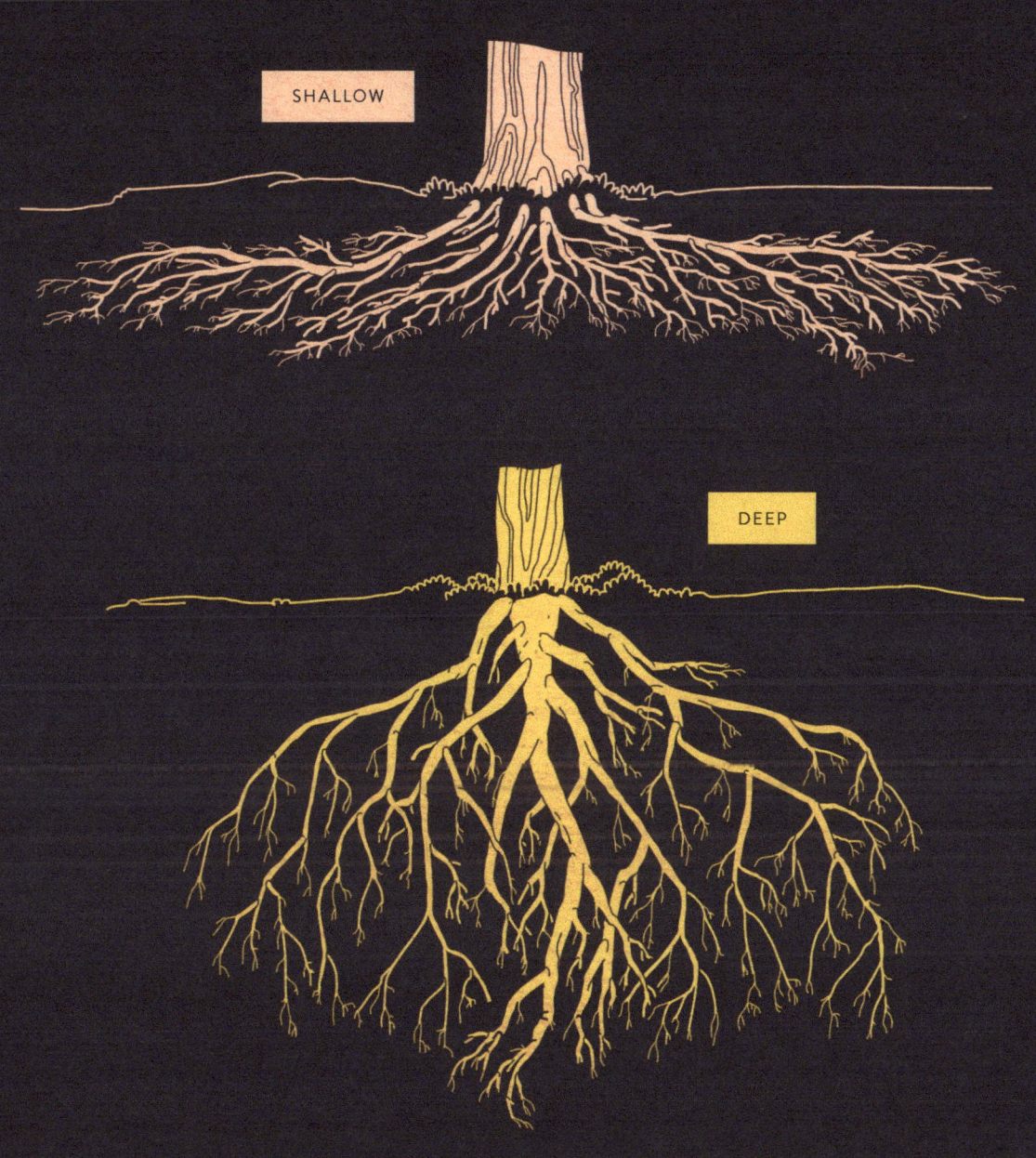

THE FRAMEWORK OF A TREE

The trunk is a big part of what makes a tree a tree. A self-supporting, woody trunk allows trees to grow upward and outcompete other plants for light. Branches spread outward, arranging leaves to minimize overlapping and optimize their sun exposure—in a bird's-eye view, looking downward from above, the leaves seem to fit together like pieces in a puzzle.

As a tree grows, the lower and inner parts of its crown become progressively more shaded, and photosynthesis levels in these areas decline. Branches that can't support themselves—where maintenance and growth require more energy than they produce—ultimately die. Leaves tend to be located at the edges of the crown, where they can gather adequate light. This process is well illustrated by the difference between the silhouettes of trees growing in open spaces, with their broad, dense crowns, and those of forest trees, with tall, narrow structures that grow in response to nearby competitors.

A tree's structure flexes with the wind, can spring back after bending under an animal's weight or a heavy load of snow, and is anchored in place by woody roots. The branches also expose leaves to air currents, which can spread pollen, distribute seeds, and promote evaporation that cools leaves and initiates the movement of water up from the roots.

CURIOUS ARTIST TIP

When drawing wood grain, remember to keep a loose hand. Wood grain usually heads in the same direction but is wobbly and imperfectly spaced—but remember that these lines almost never overlap!

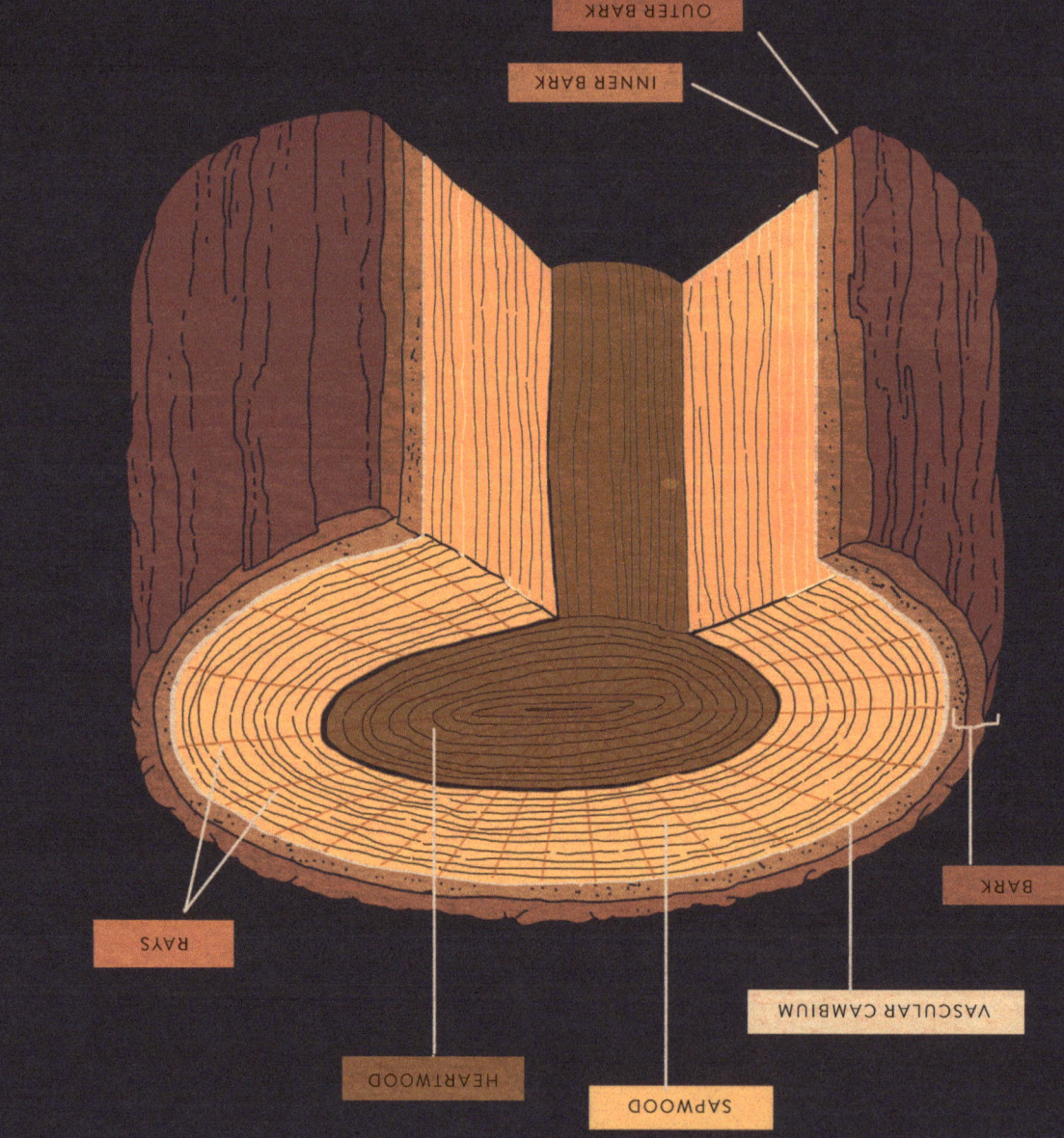

HOW TREES GROW

Trees do not get bigger by pushing upward from the ground; they grow by adding on. The trunk, branches, and roots grow longer from their tips. They grow thicker when additional layers of wood and bark are produced around their perimeter. A fence wire attached to a tree remains at the same height as a tree grows, and over time will be enveloped by new layers of bark and wood, appearing as if it was somehow threaded right through the trunk.

Almost all of the increase in girth occurs at the vascular cambium, a thin area of cell division between the wood and the bark. New layers of wood are aptly called sapwood; many of these newly produced cells, the xylem, die and form networks of tubes or vessels through which water and dissolved minerals move upward from the roots to the rest of the tree. Other cells form rays—strips of living wood that radiate from the center, like wheel spokes—that connect the xylem with the phloem of the bark and store excess food and minerals. In species such as oaks, the rays are visible as lines perpendicular to the growth rings in the wood.

As most tree species get older, their sapwood at the center is converted into heartwood, a dense, often dark core of dead cells that no longer functions as transportation or storage tissue but continues to provide structural support. Heartwood can contain a variety of compounds, such as resins and gums, which help protect the tree against infestation and infection.

GROWTH RINGS

In areas with seasonal growth periods, wood cells produced early in the season are large, with thin walls—good for moving large quantities of water during active growth—while those produced later in the season are denser, with thicker walls, and appear darker. Repeating bands of this light and dark wood create the growth rings of wood. In temperate areas, growth rings usually reflect annual growth patterns, and can be used to age a tree. In the more consistent conditions of the tropics, trees typically do not produce growth rings, or do so without an annual cadence, because they can grow all or most of the year.

Bristlecone pines, which are some of the oldest known trees, grow slowly because of their harsh environment—their growth rings can be as thin as a piece of paper. Annual growth rings can be as wide as ½ in (1.3 cm) on young giant sequoias, which can mature into some of the largest trees on Earth.

On large, old trees, the width of growth rings frequently decreases—the volume of wood produced may remain the same, but the wood must be spread around the increasingly larger circumference of the trunk, branches, and roots. Sometimes, historic events are recorded by growth rings. Most trees that were living in 1816 display stunted growth rings for that year, in response to a volcanic eruption in Indonesia that spewed clouds around the world and occluded sunlight.

RAY

ANNUAL
GROWTH RINGS

BARK

HEARTWOOD

SAPWOOD

TREE RINGS ARE OFTEN VISIBLE WHEN THE CROSS SECTION OF A TREE TRUNK IS CUT. EACH RING REPRESENTS ABOUT A YEAR OF GROWTH, SO THESE RINGS ARE ALSO CALLED GROWTH RINGS. THE SCIENTIFIC STUDY OF ANALYZING TREE RINGS TO LEARN A TREE'S AGE IS CALLED *DENDROCHRONOLOGY*.

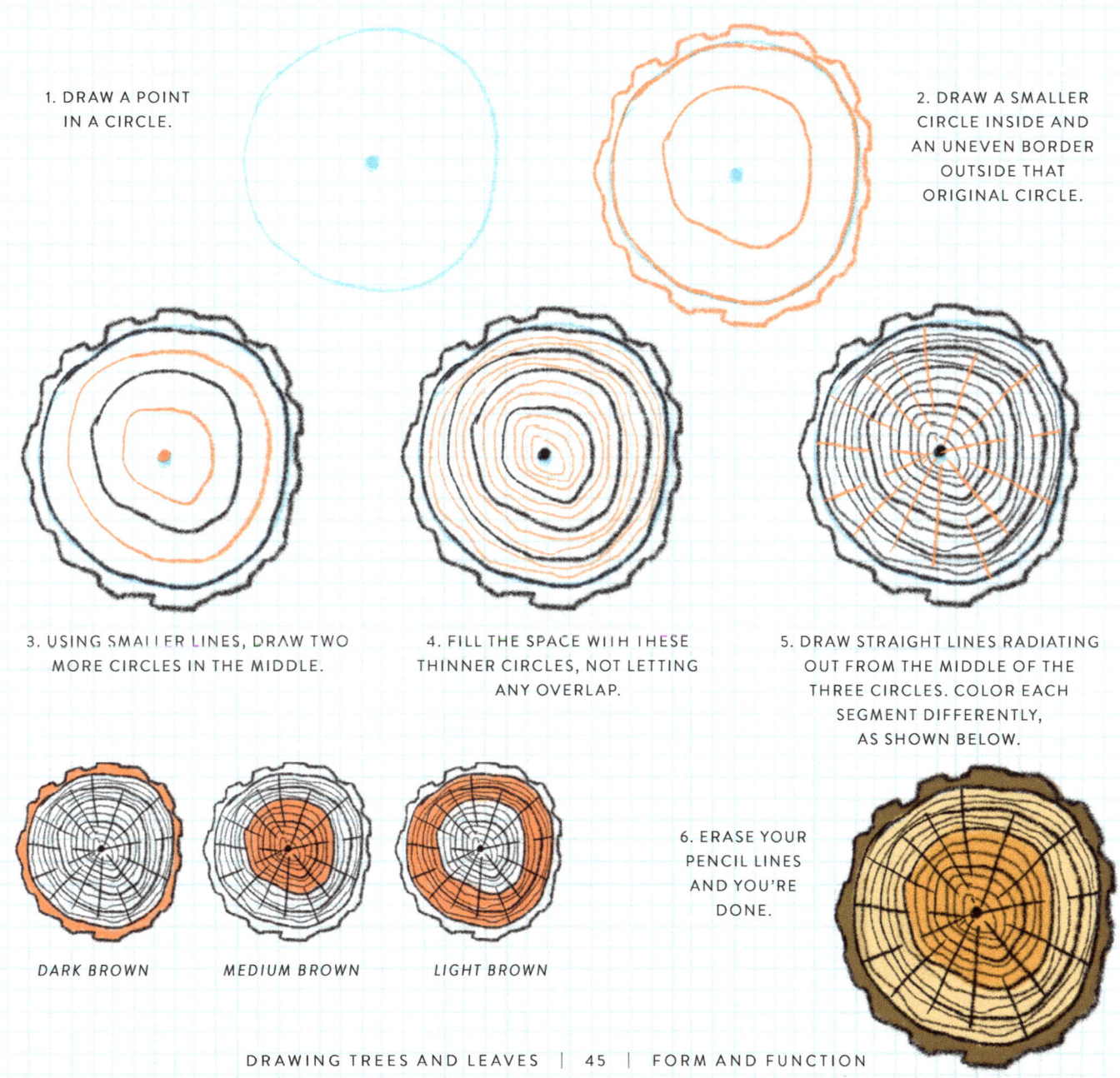

BARK

STRUCTURE

Look around at the trees in a forest and, at first glance, all of their trunks often look alike. Their bark can appear nondescript, and it typically garners less attention than their more familiar leaves, which display the characteristics we often use to identify each species, and their wood—a resource for lumber, heating, cooking, and many other things. With a little understanding of the structure of bark, and the vital functions it serves, its details come alive, providing both a means to see the trees through the forest and a bounty of colors and textures to enjoy.

Imagine the cross section of a young trunk, with the smooth, unbroken outer bark that all trees start out with. This visible, outer layer, which is composed mostly of cork cells that die soon after they mature, protects the living tissues beneath it against fungi and other infectious agents, incursion by insects and other animals, and dehydration. The cork oak, native to the Mediterranean Basin in Europe and Africa, produces an especially thick cork layer that is used to make wine corks and other products.

Beneath the cork of this young tree are living layers of bark: the cork cambium, an area of cell division and growth; on some species the cork skin, which may contain chlorophyll and have photosynthetic capabilities; and the inner layer of bark, the phloem, which transports the food produced through photosynthesis throughout the tree.

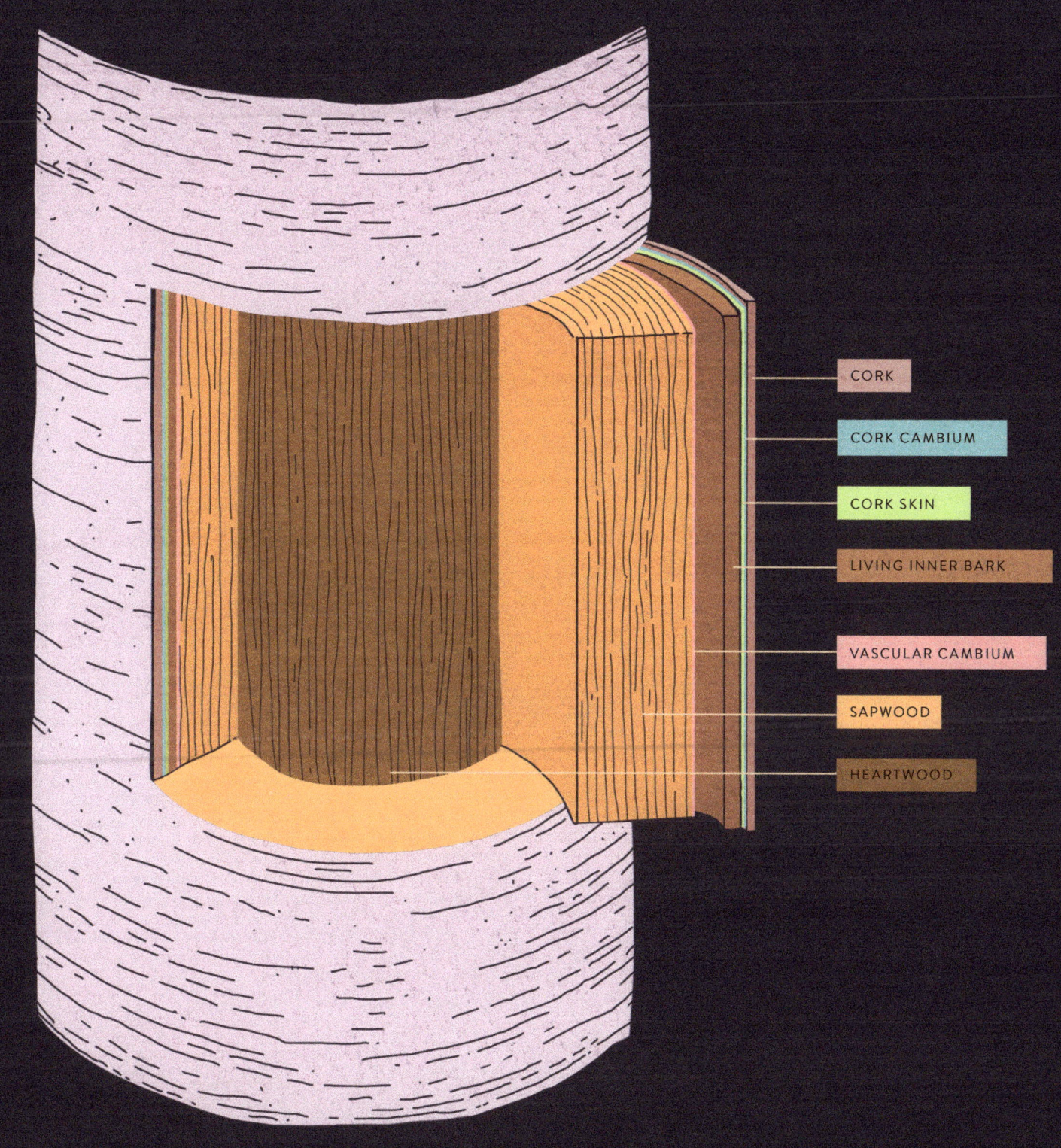

IDENTIFYING CHARACTERISTICS

For some species, especially those of tropical forests, the outer, protective bark remains smooth and unbroken for many years, often for the life of the tree. Beech trees are a good example—carving initials on their trunks, which become wider and more prominent as the bark grows around the expanding tree, is an old custom commemorated by the saying: "As these letters grow, so may our love."

Many other species, however, reach a point where the protective outer bark no longer grows fast enough to keep up with the expanding wood beneath it. The outer layer begins to crack and then break apart, but before it does, a new protective layer forms beneath it. Depending upon the species, this process can occur once or many times over the life of a tree, and will appear differently according to the cellular structure of its bark.

The outer bark might break apart into patterned scales, like those of spruce; randomly sized plates, such as those found on black birch; or vertical strips, like those of red maple and other species—all of which separate and sometimes detach from the rest of the bark. On some species, including many oaks and pines, bark layers stay tightly adhered, forming blocks or ridges that can grow thick over time. Bark appearance often changes as trees age, so young bark on the upper trunk and branches may look quite different from the older bark at the base.

CURIOUS ARTIST TIP
Imagine all the ways that you have seen different materials crack, tear, or peel. Every tree's bark has distinctly different patterns; observe your tree of choice carefully to see if you should be drawing scales, lines, or ridges.

RED SPRUCE: *GRAYISH TO REDDISH BROWN SCALES*

BEECH: *SMOOTH, LIGHT-GRAY BARK*

WHITE ASH: *RIDGED, DIAMONDLIKE PATTERN*

RED OAK: *SMOOTH, VERTICAL RIDGES*

PAPER BIRCH: *WHITE PLATES PEELING HORIZONTALLY IN CURLY STRIPS*

BLACK BIRCH: *VERTICAL CRACKS WITH IRREGULAR PLATES*

RED MAPLE: *LONG, VERTICAL STRIPS*

WHITE OAK: *GRAYISH BROWN SCALES OR BLOCKS*

RAINBOW EUCALYPTUS: *BRIGHTLY COLORED BARK SHEDS IN LARGE SLABS, RIBBONS, OR SMALL FLAKES*

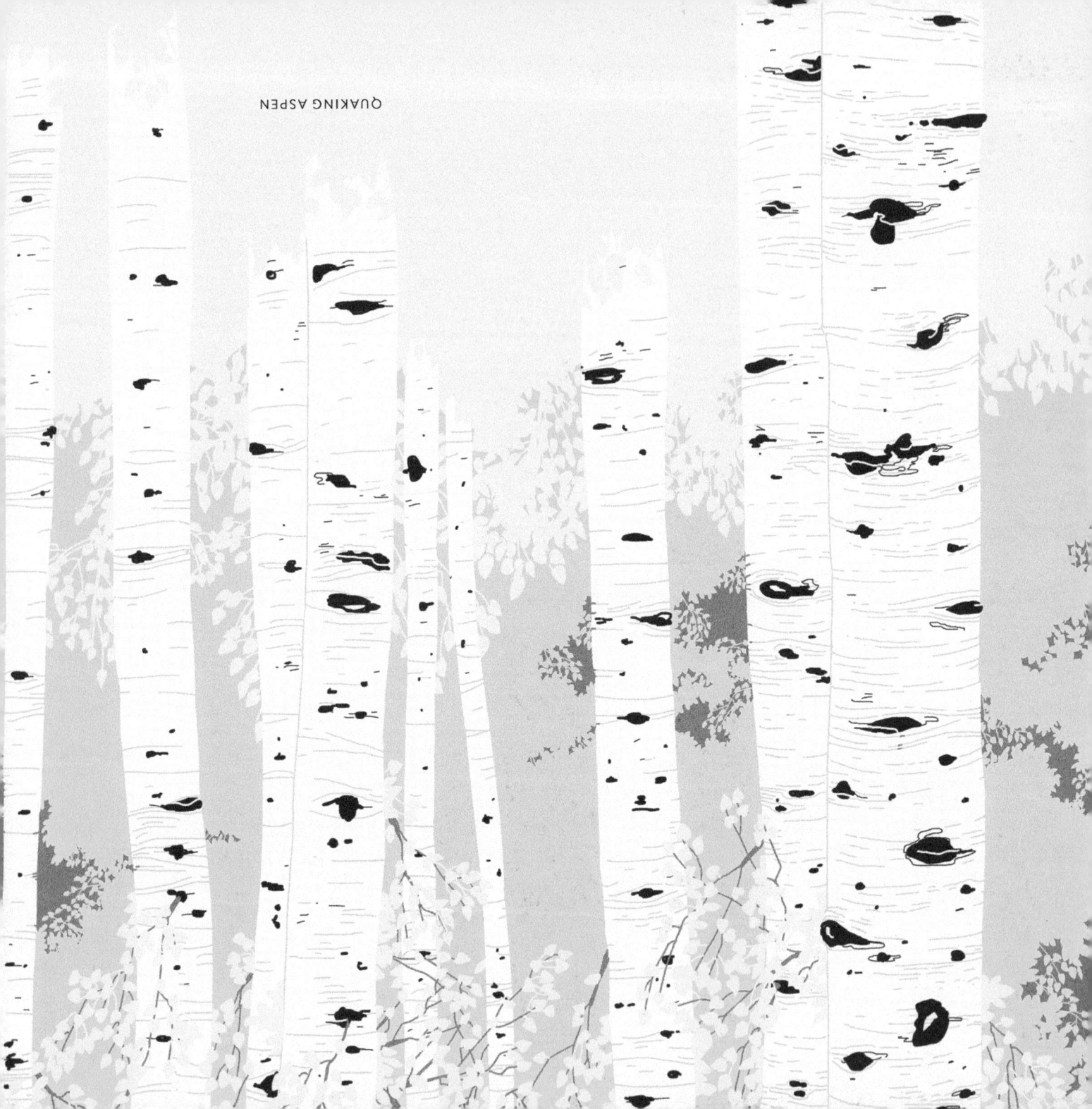

BARK ECOLOGY

Each tree species has developed bark characteristics in response to the conditions in which it has evolved. The thick, multilayered blocks of outer bark of pitch pine and giant sequoia, for example, help insulate the trunk against ground fires, which are a natural component of their ecosystems. Bark also helps insulate against sunscald and frost cracks—wounds caused by swift expansion or contraction of bark due to rapid temperature fluctuations.

In addition to maintaining a mechanical barrier, bark provides chemical protection. The bark of trees in the willow family contains salicin, a compound that deters bacteria, fungi, and insects. Salicin has long been used by humans as a pain reliever, and is the precursor to synthetically produced aspirin. Tannins in hemlocks, oaks, and other species deter invaders and ward off browsing animals.

Although thin bark is generally less protective than thicker bark, for some species, such as beech, it provides an advantage. Beneath their protective outer bark is a thin, green, photosynthetic layer that can provide some supplemental energy. The thin bark allows a small amount of sunlight to pass through and reach this layer, even on the trunk. Energy from bark photosynthesis can help trees recover from defoliation due to storms, insect infestations, or severe drought, and can be crucial to survival for species growing in harsh conditions, such as paper birch and quaking aspens found at high latitudes and upper elevations.

HOW TO DRAW
SWEET CHERRY TREE BARK
Prunus avium

SMOOTH, REDDISH BROWN BARK OFTEN PEELS FROM THE TRUNK

FRUIT IS A RED TO PURPLE ROUND DRUPE, WITH A SINGLE, HARD, ELLIPTICAL STONE (CONTAINING THE SEED)

OVAL, POINTED, DULL GREEN LEAVES HAVE SERRATED EDGES

WHITE FLOWERS HAVE FIVE ROUNDED PETALS WITH TWO TO SIX FLOWERS ON EACH STALK

STRAIGHT TRUNK, ROUNDED CROWN

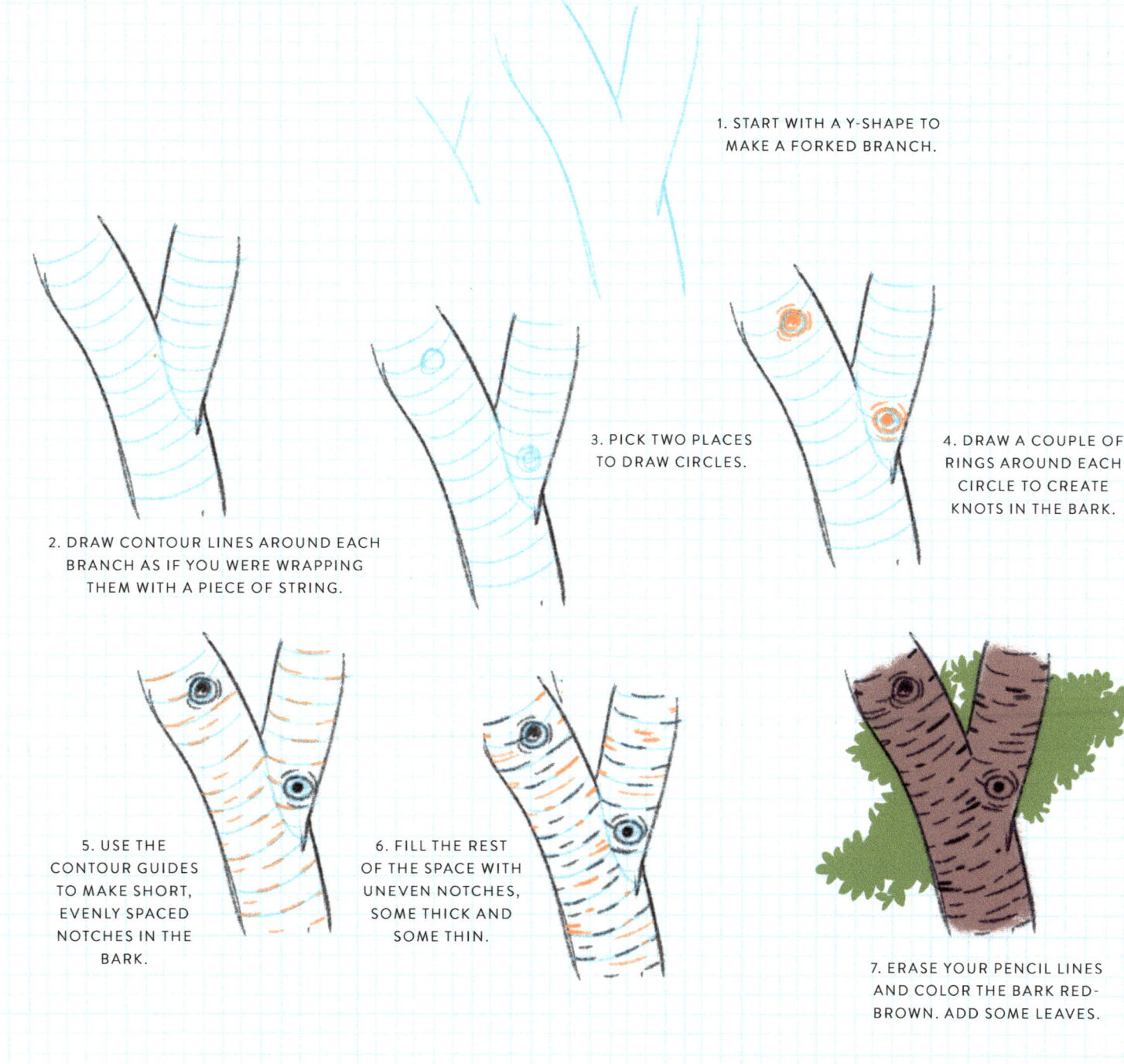

HOW TO DRAW
SHAGBARK HICKORY TREE BARK
Carya ovata

MALE FLOWERS OCCUR AS THREE DROOPING CATKINS ON ONE STALK

FEMALE FLOWERS OCCUR IN SHORT SPIKES AT THE TIPS OF NEW SHOOTS

TALL, NARROW TRUNK; IRREGULAR CROWN; LARGE DECIDUOUS TREE

LONG, YELLOW-GREEN, PINNATE LEAVE S HAVE FIVE TO SEVEN LEAFLETS

MATURE TREES HAVE DISTINCTLY ROUGH, SHAGGY, LIGHT GRAY BARK THAT SEPARATES INTO LONG, NARROW, CURVED STRIPS

THE HICKORY FRUIT IS A DRUPE WITH A THICK HUSK. THE EDIBLE NUT IS LIGHT BROWN AND ELLIPTICAL

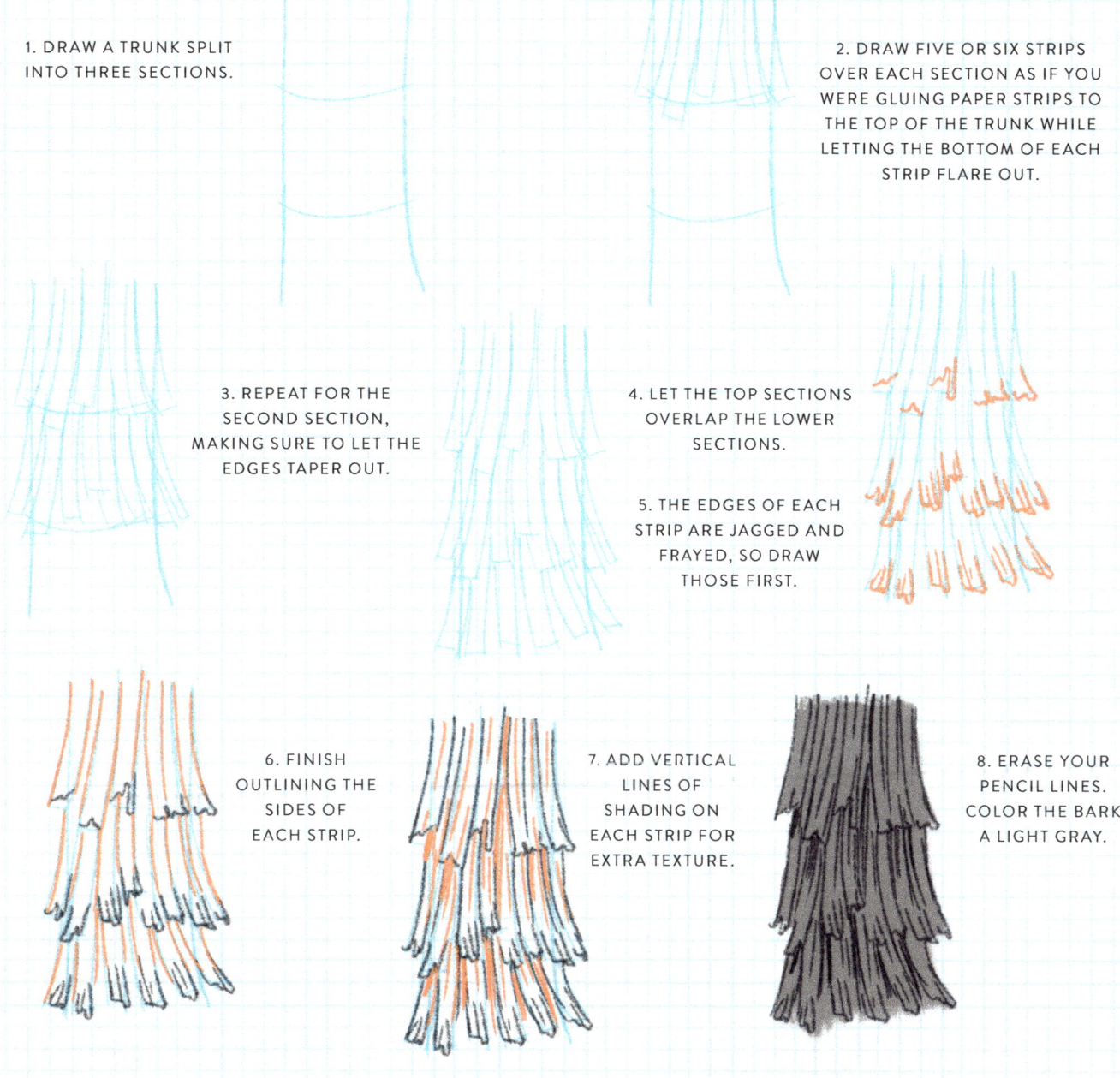

DRAWING TREES AND LEAVES | 55 | FORM AND FUNCTION

LEAVES

CURIOUS ARTIST TIP

When drawing leaf buds, think about the bud shapes of different trees. The beech bud is long and pointy, but the ash bud is more like a round droplet.

BUDS

The leaves of trees typically go unnoticed until they burst from their buds, covering spring landscapes with a flourish of green or adding to evergreen forests without distinct growing seasons. Much growth and development, however, have already taken place by the time leaves appear. A look inside these buds, perhaps with the aid of some magnification, would reveal fully formed, miniature leaves that already show characteristic species traits—maybe the lobed shape of a maple leaf or a willow's narrow, lancelike profile.

Inside buds, leaves grow folded and packed according to intricate patterns so specific that they warrant their own set of botanical terms. Beech leaves grow in a plicate pattern—pleated along a central rib—and are involute, or curled inward at their edges. One theory holds that the specific leaf shape of each species is derived, at least in part, from the need for efficient folding and packing patterns within the bud.

On some tree species, the entire year's twigs and leaves are preformed in buds that sprout in a single flourish each spring. Afterward, the following year's buds begin to grow. Other species have multiple blooms before producing buds. Warmer-sited and more tropical species typically have cycles of growth that are less seasonally dependent.

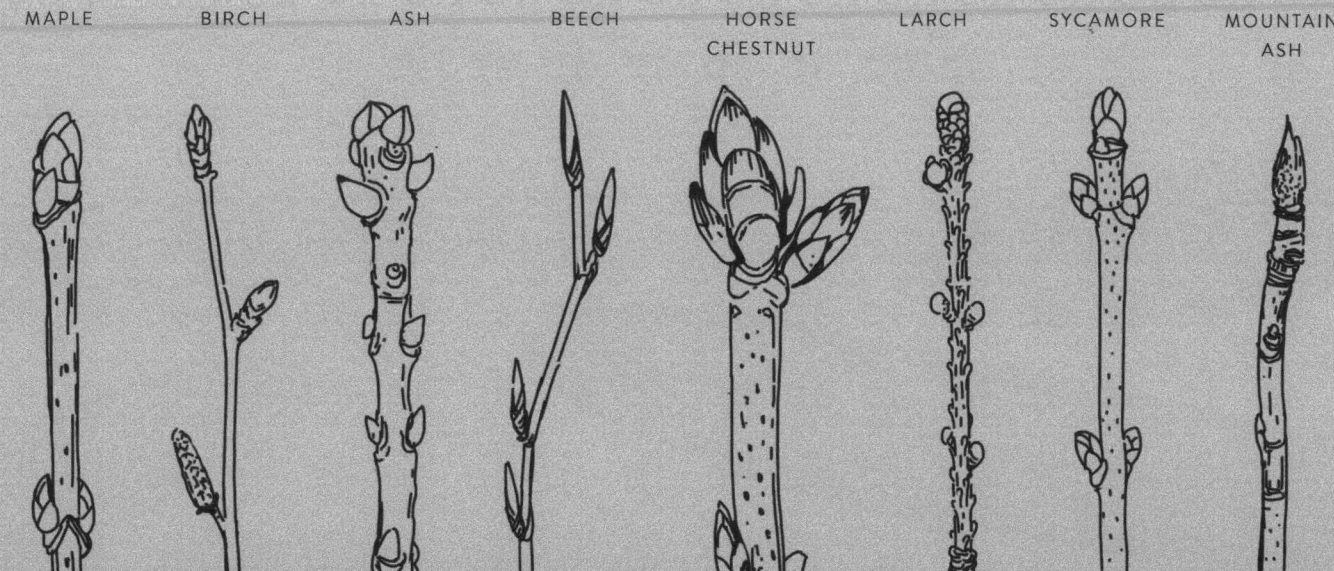

MAPLE BIRCH ASH BEECH HORSE CHESTNUT LARCH SYCAMORE MOUNTAIN ASH

STOMATA ON AN
EASTERN HEMLOCK

LEAVES AND COLOR

Young leaves can range in color from white to pale greens, reds, or browns, creating a springtime colorscape in some regions. The green color of most mature leaves comes with the formation of chlorophyll, which captures the sun's energy during photosynthesis. Chlorophyll absorbs sunlight in the blue and red spectrums; we see the green wavelengths that reflect off or pass through the leaf. As the leaves of deciduous trees begin to die in autumn, they lose their green color as chlorophyll is broken down and taken back into the tree for future reuse, revealing previously masked yellows and reds, or combinations of the two that yield oranges, purples, and even blues.

CURIOUS ARTIST TIP

The stomata on the eastern hemlock are arranged pretty neatly in rows, but much like everything in nature, they'll never be perfectly symmetrical, so don't worry about the slight irregularities when you're drawing by hand.

WHITE
LIGHT

CHLOROPHYLL

HOW PHOTOSYNTHESIS WORKS

A waxy, water-resistant cuticle protects the surface of leaves. This cuticle usually grows thicker on leaves exposed to dry, sunny conditions, giving them a glossy appearance. Small pores called stomata, the Greek word for "mouths," allow the gases necessary for photosynthesis to pass through the cuticle, and are usually concentrated on the undersides of leaves. Individual stomata require magnification to see, but rows of them show up as white lines on the needles of eastern hemlock and some other conifers.

When stomata open during photosynthesis, water vapor escapes from the leaf in a process called transpiration, which cools the leaf and helps keep it from overheating. As leaf cells dry out, they pull water from adjacent cells, creating tension, or suction, that draws a column of water from cell to cell up from the roots. Through transpiration, water can be pulled to the tops of the tallest trees, many feet (meters) above the ground.

On a summer day, 50 to 100 gal (200 to 400 L) of water might flow through an isolated tree, in the process distributing vital minerals absorbed by the roots. If the transpiration rate begins to outpace water uptake by the roots, leaves curl and wilt to decrease sun exposure and water loss. Continued water deficits cause stomata to close, increasing the risk of overheating; photosynthesis rates slow or halt, and growth can be inhibited.

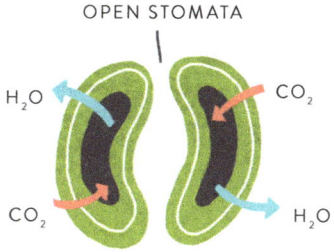

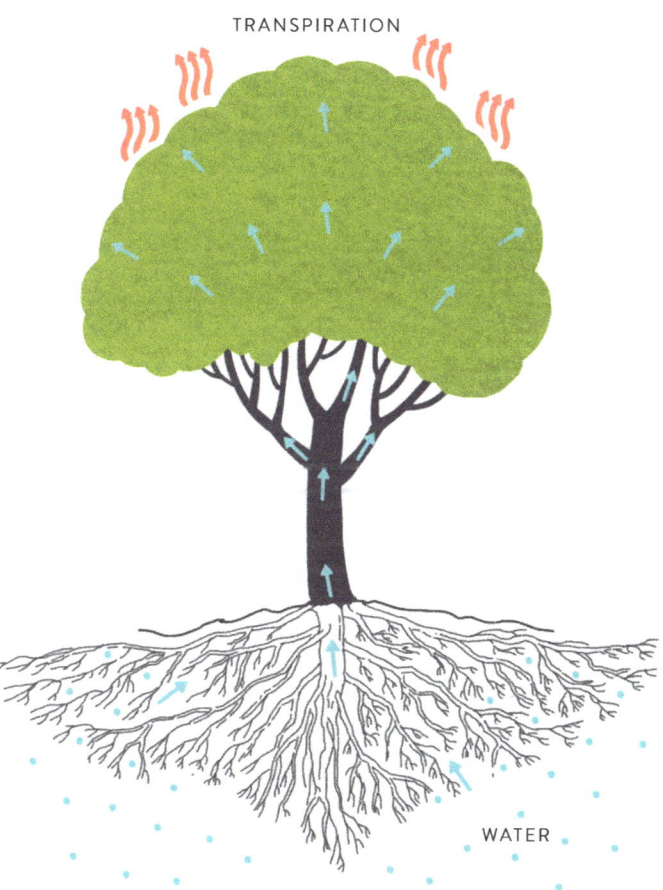

LEAF VARIATIONS

Many of the different leaf structures and shapes found among species, as well as on individual trees, are functional adaptations—they help trees manage water flow and allow them to maintain higher food- production levels.

The leaves of many species, especially when they are young and most vulnerable, have small hairs on the surface that reflect light and slow evaporation. Species with small leaves, or those that are lobed or have toothed edges, can better tolerate drier conditions. Because cooling air currents move more easily across their surface, there is less need to release water to prevent overheating. Needles and scales, such as those found on pine and cypress, are compact leaves that enable some species to withstand especially dry, cold, or windy conditions. Tree species growing in shaded, more humid habitats, where water loss is less critical, tend to have large, flat leaves that maintain higher temperatures, which in turn increase photosynthesis and transpiration rates.

The size and structure of leaves from a single tree can vary to such a degree that samples from different locations within the crown might appear to represent different species. Sun leaves in the upper and outer crown tend to have deeper lobes and less surface area—traits that help mitigate overheating and water loss and allow more light to reach the larger, less deeply lobed, shade leaves beneath them. Shade leaves are typically thinner and darker green and are better at processing the lower intensity, dappled sunlight that reaches them.

CURIOUS ARTIST TIP | *Leaves are much more fun to draw when they're not simple ovals. When drawing oak leaves, the irregular lobes are key—but don't forget to draw the stem down the middle!*

ELLIPTIC
OVAL SHAPED

OVATE
*A ROUND
BASE WITH A
TAPERED TIP*

FALCATE
CURVED OR HOOKED

LINEAR
*NARROW WITH A
CONSISTENT WIDTH*

OBLONG
*ELONGATED, WITH
PARALLEL SIDES*

SPEAR SHAPED

DELTOID
TRIANGULAR

ACICULAR
NEEDLE SHAPED

OBOVATE
*EGG SHAPED WITH
A NARROWER BASE*

FLABELLATE
FAN SHAPED

CORDATE
HEART SHAPED

SPATULATE
*WITH A BROAD,
ROUNDED END*

ORBICULAR
CIRCULAR

RENIFORM
KIDNEY SHAPED

RHOMBOID
DIAMOND SHAPED

PALMATELY COMPOUND
*LEAFLETS RADIATING
FROM A CENTRAL POINT
ON A LEAFSTALK*

PINNATELY LOBED
*LOBES ON EITHER SIDE
OF A CENTRAL AXIS*

DIGITATE
*SHAPED LIKE A
SPREAD-OPEN HAND*

PALMATELY LOBED
*LOBES RADIATING
FROM A CENTRAL
POINT*

PINNATELY COMPOUND
*A ROW OF LEAFLETS ON
EITHER SIDE OF A STEM*

HOW TO DRAW
BASIC LEAF SHAPES

Try drawing some of the leaf shapes shown above. Many leaves resemble simpler shapes, so start there, and then add the stem and color. You can also start by tracing the outlines of a few leaves to get a feel for their overall shapes.

1. TO DRAW A PALMATELY LOBED LEAF, START WITH A CIRCLE.

2. PLACE A DOT IN THE CENTER OF THE CIRCLE. ADD FIVE POINTS AROUND ITS CIRCUMFERENCE, PLACING TO MIMIC THE POINTS OF A STAR.

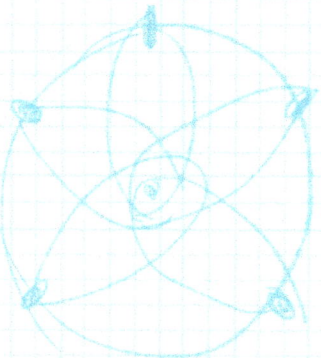

3. USE THOSE GUIDES TO MAKE FIVE POINTED OVALS, ALL INTERSECTING IN THE MIDDLE.

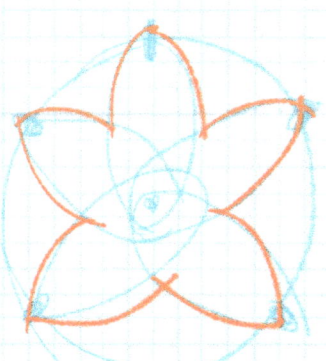

4. OUTLINE THE ROUNDED STAR SHAPE OF THE FIVE OVALS.

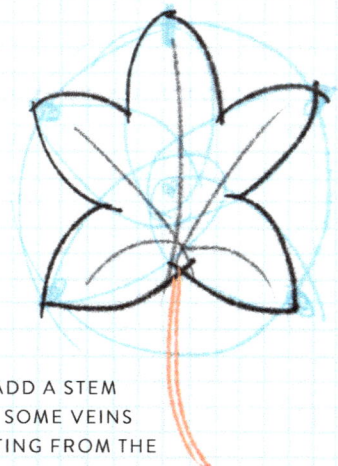

5. ADD A STEM AND SOME VEINS RADIATING FROM THE CENTER OF THE BASE.

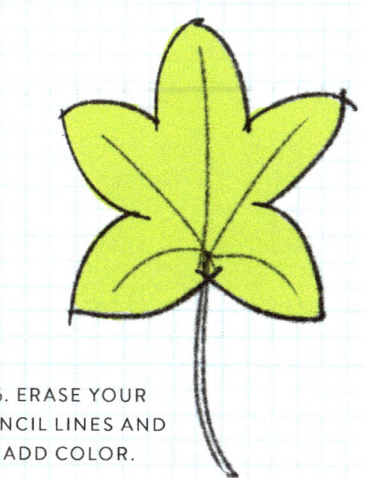

6. ERASE YOUR PENCIL LINES AND ADD COLOR.

DRAWING TREES AND LEAVES | 63 | FORM AND FUNCTION

HOW TO DRAW
DOUGLAS FIR NEEDLES
Pseudotsuga menziesii

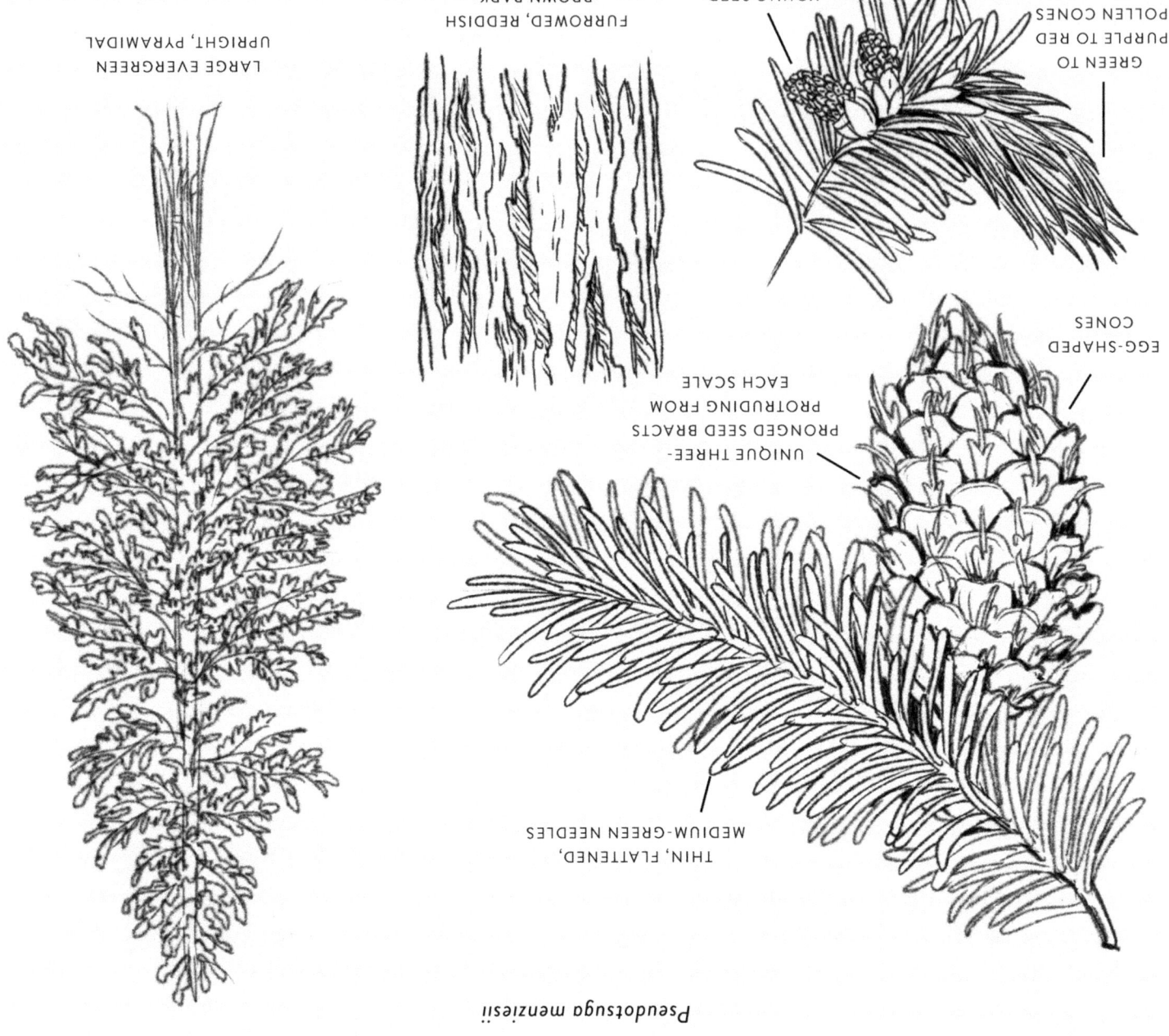

- LARGE EVERGREEN UPRIGHT, PYRAMIDAL
- FURROWED, REDDISH BROWN BARK
- YOUNG SEED CONES
- GREEN TO PURPLE TO RED POLLEN CONES
- EGG-SHAPED CONES
- UNIQUE THREE-PRONGED SEED BRACTS PROTRUDING FROM EACH SCALE
- THIN, FLATTENED, MEDIUM-GREEN NEEDLES

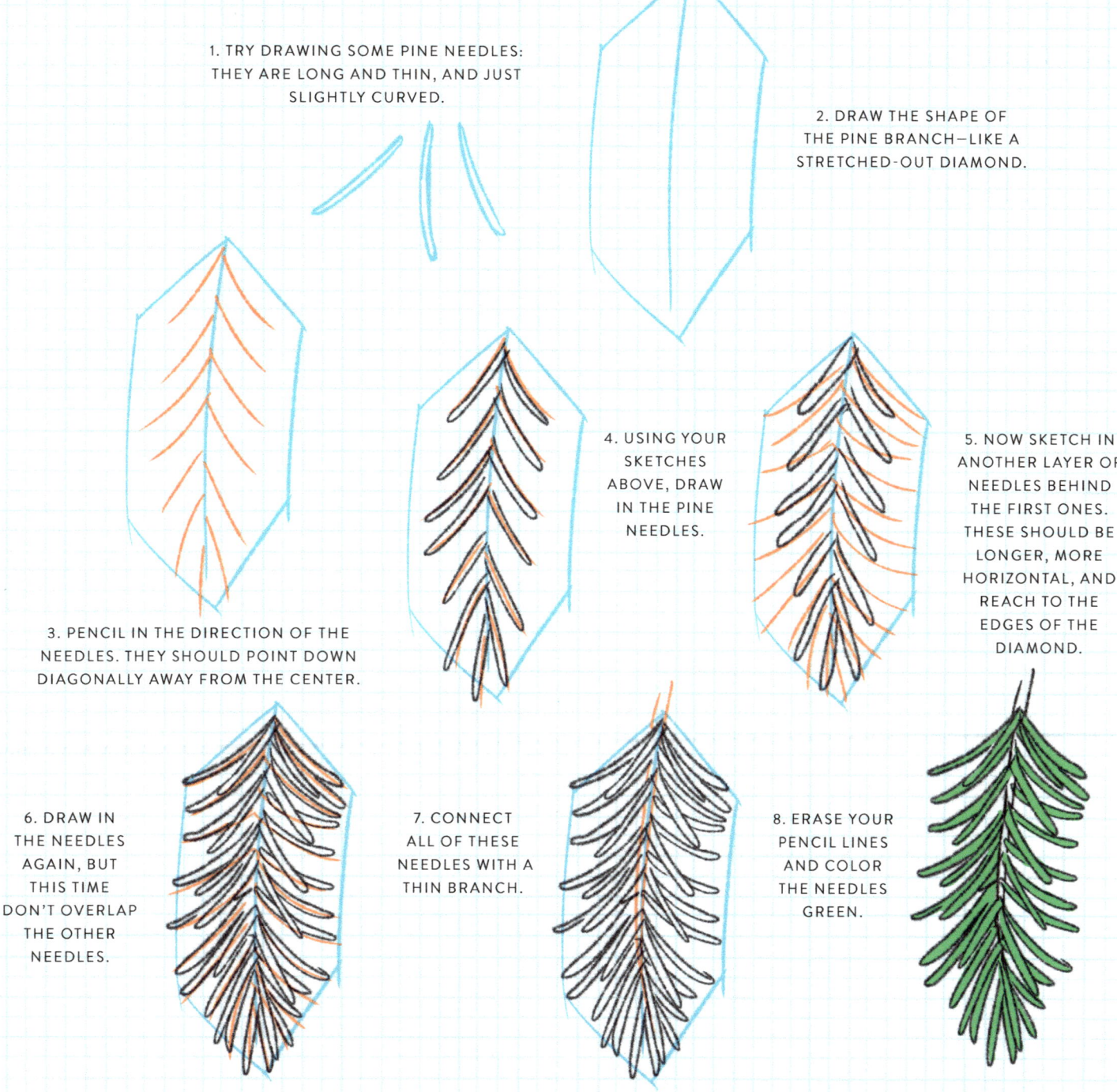

DRAWING TREES AND LEAVES | 65 | FORM AND FUNCTION

HOW TO DRAW
GINKGO LEAVES
Ginkgo biloba

CATKINS ON MALE TREES

TAN-ORANGE SEEDS ON MATURE FEMALE TREES, TWENTY YEARS OR OLDER

VEINS MAKE THE LEAVES LOOK RIBBED

A SINGLE (SOMETIMES DOUBLE) VERTICAL SLIT IN THE CENTER

THICK, FURROWED, AND RIDGED BARK

FAN-SHAPED LEAVES

UPRIGHT, COLUMNAR

LARGE SHADE TREE

NORMALLY MEDIUM GREEN, THE LEAVES TURN A GOLDEN YELLOW TO CHARTREUSE COLOR IN THE FALL

1. GINKGO LEAVES ARE SHAPED LIKE FANS OR SLICES OF PIE. TO START, DRAW A STEM SPLITTING THE PIE SLICE IN HALF.

2. THERE'S USUALLY A V-SHAPED NOTCH WHERE THE LEAF MEETS THE TOP OF THE STEM.

3. THE TOP OF THE LEAF IS SCALLOPED. TRY TO FIT IN FOUR OR FIVE CURVES ON BOTH SIDES OF THE NOTCH.

4. GIVE A CURVE TO THE BOTTOM OF THE LEAF AND DRAW A THIN STEM.

5. GINKGO LEAVES HAVE PROMINENT VEINS. LET THEM RADIATE OUT FROM THE STEM TO THE LEAF EDGE.

6. ERASE YOUR PENCIL LINES. COLOR THE LEAVES YELLOW OR GREEN.

DRAWING TREES AND LEAVES | 67 | FORM AND FUNCTION

FLOWERS AND FRUIT

CONES AND FLOWERS

The reproductive structures of gymnosperms, including conifers such as pine and cypress, are technically not flowers. Conifers produce bright yellow, purple, or red pollen cones that, when viewed up close, can be as striking and beautiful as flowers. Yet pollen cones often go unnoticed—they usually grow on the upper branches and wither away after releasing their pollen.

More familiar are the seed cones of conifers, which typically persist—either on the branch or after falling from the tree. They contain ovules that are fertilized by pollen and become seeds. These cones are constructed of scales that grow around a central axis; seeds grow resting on the surface of these scales and are released when the cone opens. Both pollen cones and seed cones are usually found on the same tree.

The seeds of flowering trees, referred to as angiosperms, develop within a protective ovary, providing benefits that help angiosperms outcompete gymnosperms in many regions. Once fertilization by pollen occurs, the ovary develops into a coating, or fruit, that further protects the seeds and attracts animals that can disperse them.

Many tree species have perfect flowers, where the male, pollen-releasing structures—the stamens—and the female components of the pistil are functional. Some species have separate pollen and seed flowers. Both types may grow on the same tree or, for species such as American holly and mulberry, they occur on separate trees—both a male and a female tree are needed to produce seeds and fruit.

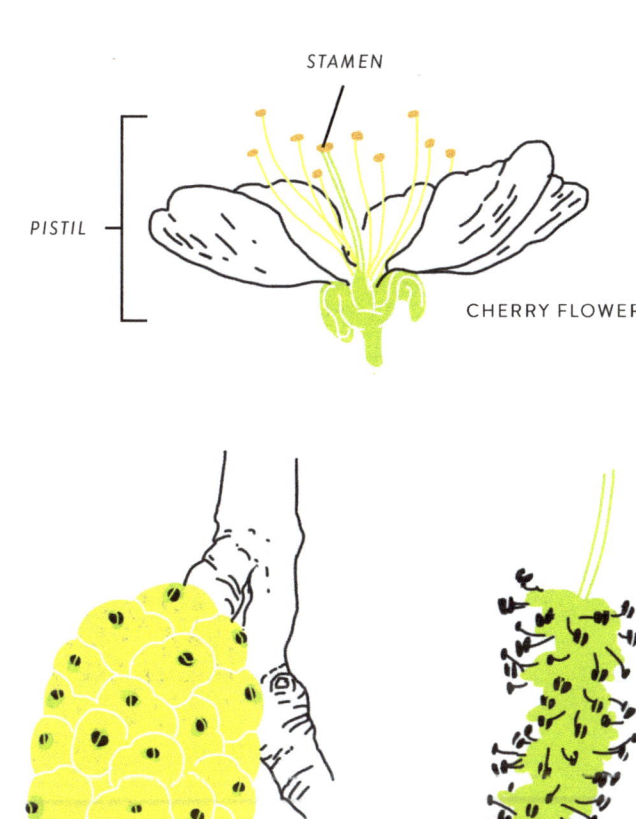

CHERRY FLOWER

FEMALE MULBERRY FLOWER

MALE MULBERRY FLOWER

BROAD-BILLED HUMMINGBIRD

POLLINATION

Some tree species rely primarily on the wind to transfer their pollen between cones or flowers, from tree to tree. Wind pollination can appear to be a highly inefficient system—pollen takes a good deal of energy to produce, and most pollen randomly blowing on the wind fails to reach a seed cone or flower to fertilize. Most wind-pollinated species are found in temperate forests and grow in high enough densities that each tree's pollen has a good chance of reaching another of its kind by traveling on the wind.

When thousands of flowers fill the canopies of wind-pollinated trees, they can easily be missed. Many of these flowers are still recognizable, upon close inspection, by their functional stamens or pistils. Although not showy themselves—these flowers often lack brightly colored petals and alluring scents—they can be spectacular in their magnitude.

Some temperate tree species, and most found in the tropics, rely on animals to distribute their pollen. Most of these species grow as widely scattered individuals, and wind pollination would have a low probability of success. Instead of producing copious amounts of pollen, these species invest in flowers that attract insects, birds, bats, and other mammals by their color, scent, or taste. Both the wind and the animals pollinate some species, such as willows, with the balance between each changing according to environmental conditions.

CURIOUS ARTIST TIP

Peach blossoms have five petals that curve in toward the center; imagine the base of the petals coming together to create a bowl-like shape. Your drawings can show this best when the flower points away from the viewer.

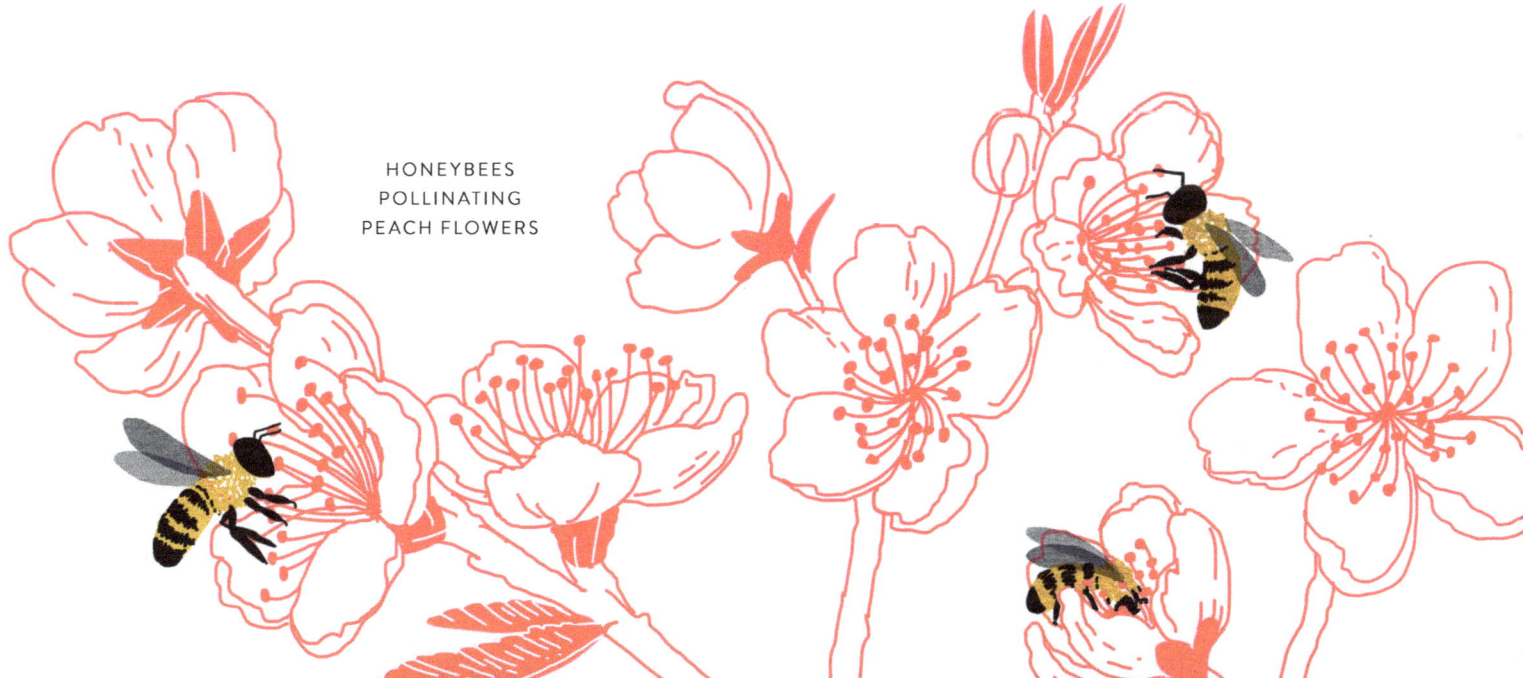

HONEYBEES POLLINATING PEACH FLOWERS

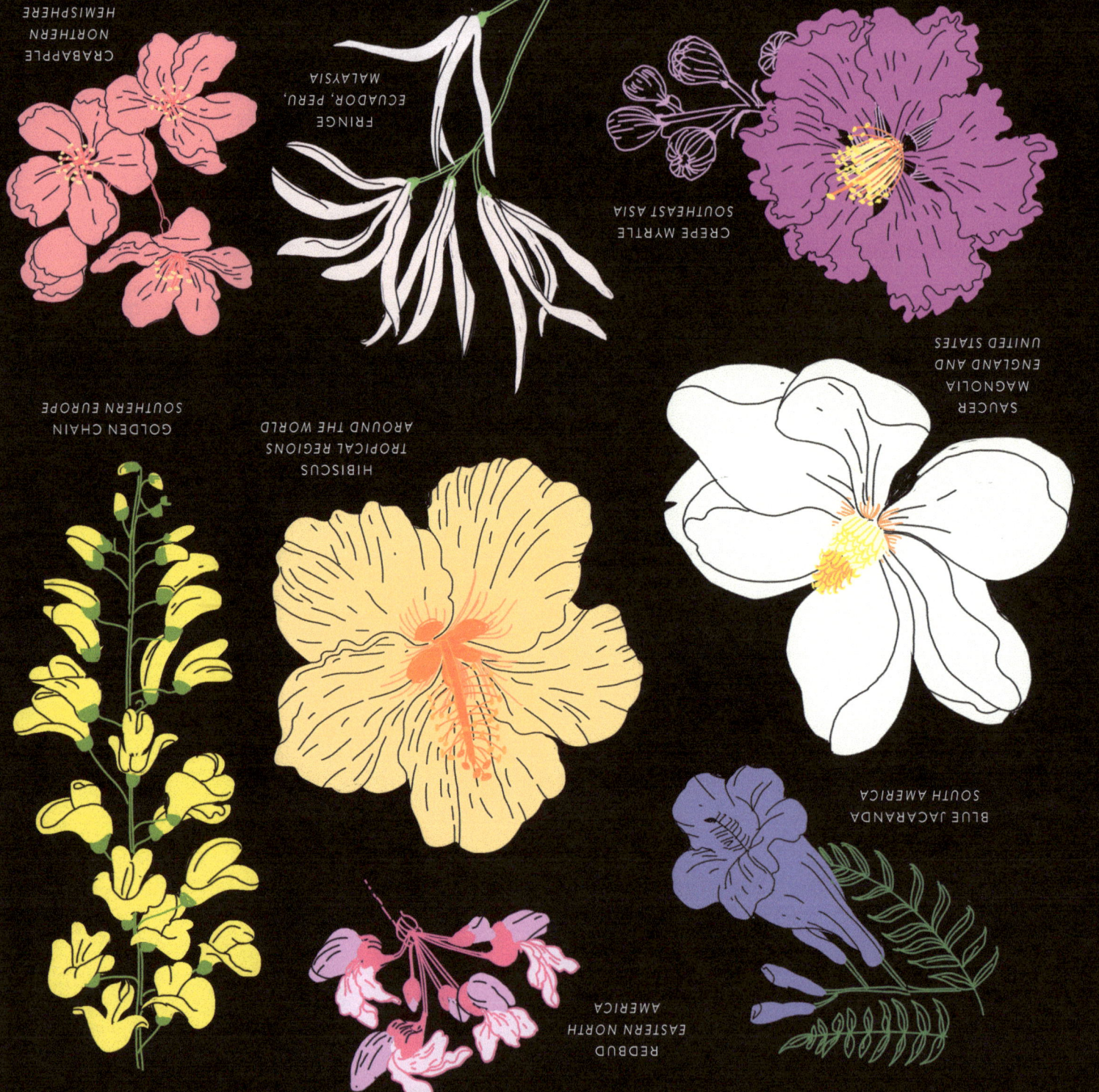

HOW TO DRAW
CRABAPPLE BLOSSOMS
Malus hopa

1. TO DRAW A CRABAPPLE BLOSSOM, DRAW A CIRCLE.

2. DRAW FIVE OVALS WITHIN THE CIRCLE, ALL OVERLAPPING IN THE CENTER.

3. OUTLINE ONE PETAL, MAKING THE INSIDE NARROW AND THE EDGES WAVY AND IMPERFECT.

 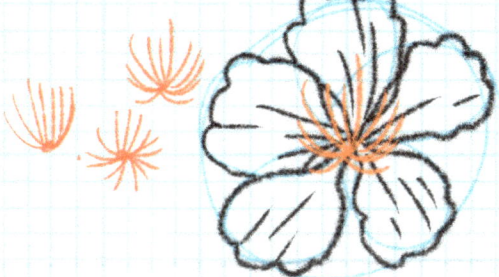

4. ADD OTHER PETALS, LETTING THEM OVERLAP IN SOME PLACES.

5. ADD SOME RIDGES IN THE PETALS RADIATING FROM THE CENTER.

6. TRY DRAWING A COUPLE OF VERSIONS OF THE FILAMENT COMING FROM THE CENTER OF THE FLOWER.

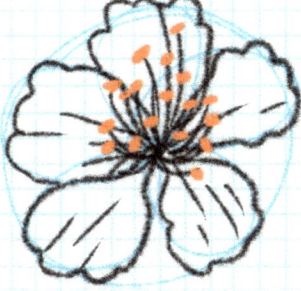 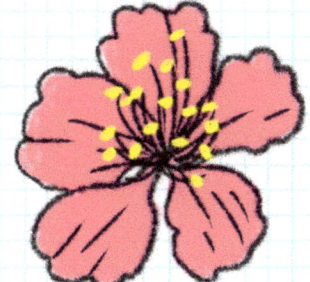

7. ADD A LITTLE OVAL TO THE TOP OF EACH LINE. THIS IS THE ANTHER ABOVE THE FILAMENT.

8. ERASE YOUR PENCIL LINES AND COLOR YOUR CRABAPPLE BLOSSOM PINK.

DRAWING TREES AND LEAVES | FORM AND FUNCTION

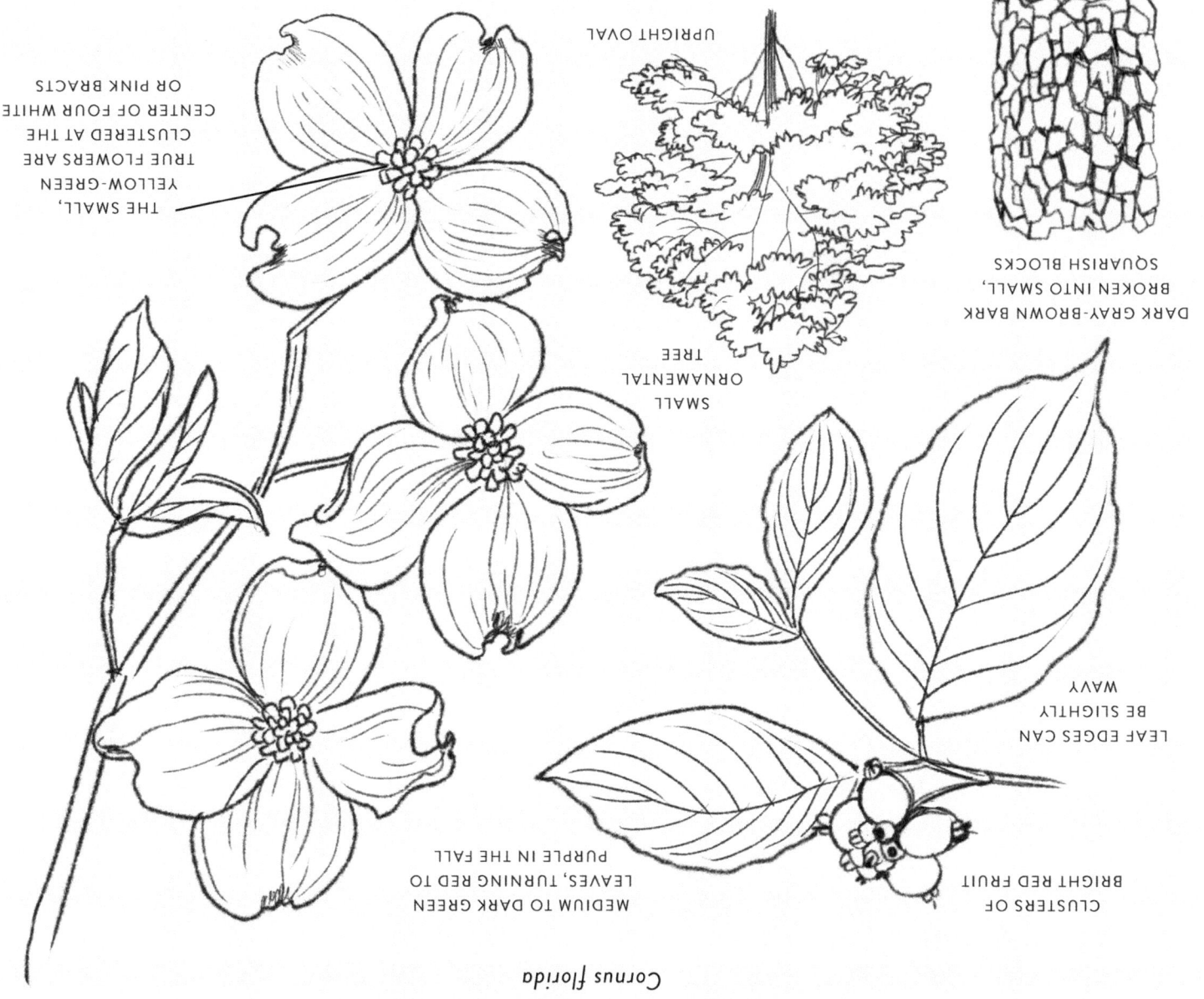

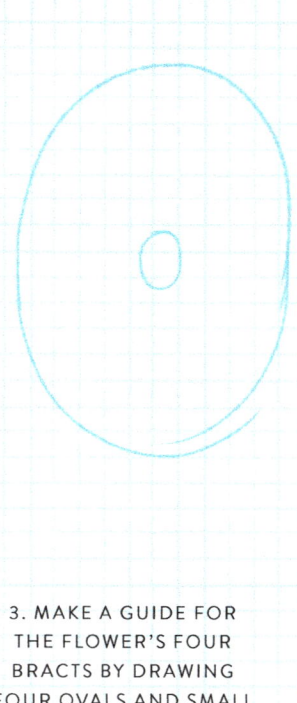

1. START WITH A SMALL OVAL INSIDE A BIGGER OVAL.

2. FILL THE SMALL OVAL WITH LITTLE CIRCLES. THESE ARE THE TRUE FLOWERS.

3. MAKE A GUIDE FOR THE FLOWER'S FOUR BRACTS BY DRAWING FOUR OVALS AND SMALL NOTCHES IN EACH OVAL.

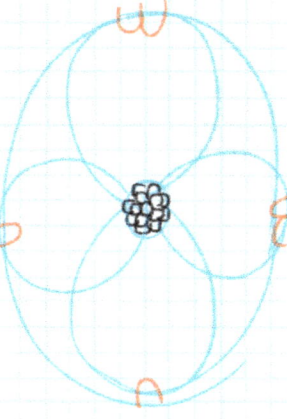

4. USING THE GUIDES FROM STEP 3, OUTLINE EACH BRACT. LET SOME BRACTS OVERLAP.

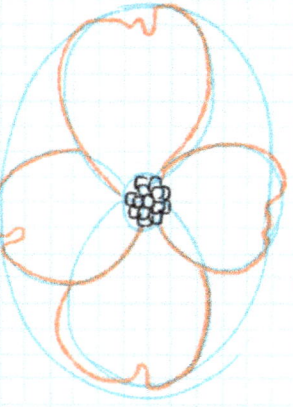

5. DRAW SOME CURVED LINES IN EACH BRACT COMING OUT FROM THE MIDDLE.

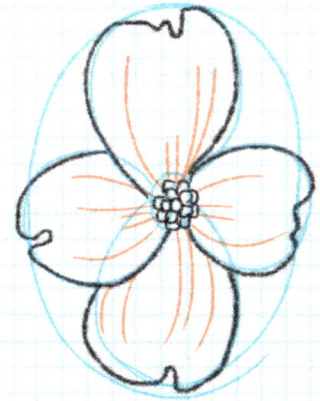

6. ERASE YOUR PENCIL LINES AND COLOR THE TRUE FLOWERS YELLOW-GREEN. ADD SOME RED TO THE TIPS OF THE FOUR BRACTS.

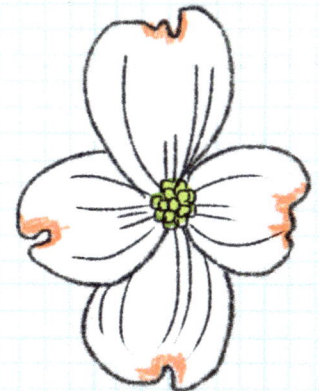

DRAWING TREES AND LEAVES | 75 | FORM AND FUNCTION

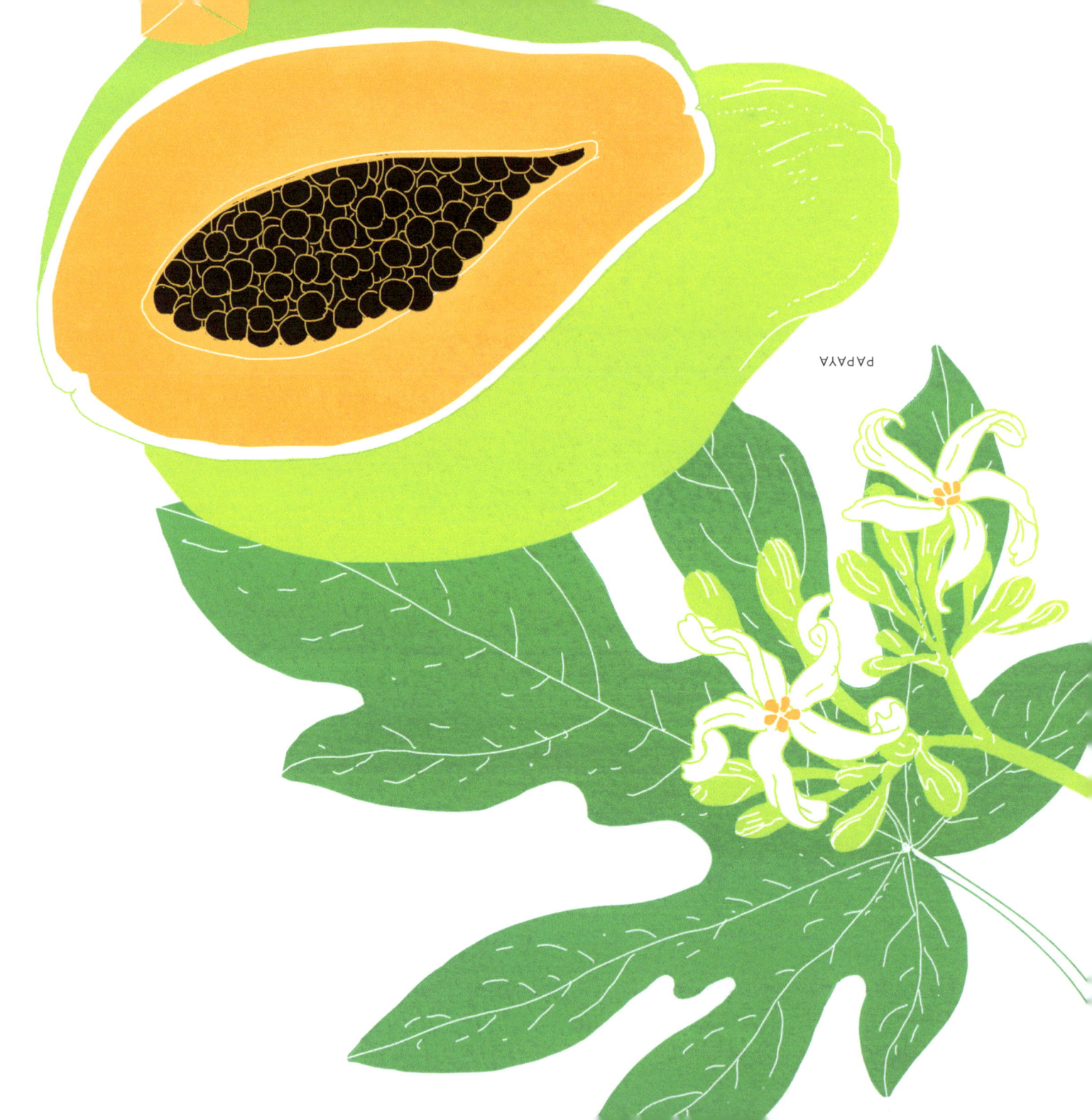

PAPAYA

FRUIT

As the seeds of flowering trees mature, the ovary surrounding them develops into a fruit, which encloses and protects the seeds within it and attracts animals that help disperse the seeds. The seeds of conifers are protected while they develop within the seed cone, but once released they are subject to the elements.

When we think of tree fruits, those that we eat likely come to mind. Fruits such as apricots and mangoes have a tasty, fleshy outer layer. A hard layer called the stone surrounds the seed within. The seeds of oranges, bananas, mulberries, and other fruits are found within the edible flesh.

What we consider the core of apples and pears is technically the fruit; the fleshy outer layer that we eat grows up from the base of the flower and surrounds the core. With fruits, such as walnuts and almonds, we discard the fleshy exterior, break open the stone, and eat the seed inside it.

Many fruits have dry and often tough outer layers. Trees in the pea family, such as acacia, produce seeds contained within a pod. The fruits of maple and ash, called samaras, are elongated into a wing to help disperse the seeds. Even acorns are fruits, with their thin outer layer encasing the large seed within.

SOME FRUIT TYPES

A *berry* is a single fruit with many seeds and without a stone.
A *hesperidium* is a berry with a tough rind.
A *pome* is a fruit with a thick skin. Seeds are in a chamber in the middle of the fruit.
A *drupe* is a single fruit with one seed inside a hard stone.
A *multiple fruit* is a collective mass formed from a cluster of flowers.

PEACH
DRUPE

LEMON
HESPERIDIUM

CHERRY
DRUPE

PEAR
POME

POMEGRANATE
BERRY

KIWI
BERRY

LYCHEE
BERRY

WAX APPLE
BERRY

FIG
MULTIPLE FRUIT

AVOCADO
DRUPE AND BERRY

PERSIMMON
BERRY

HOW TO DRAW
WILLIAMS PEARS
Pyrus communis

1. USE TWO CIRCLES OF DIFFERENT SIZES TO CREATE YOUR PEAR SHAPE.

2. DRAW A LINE DOWN THE MIDDLE AND OUT THROUGH THE TOP TO CREATE THE STEM.

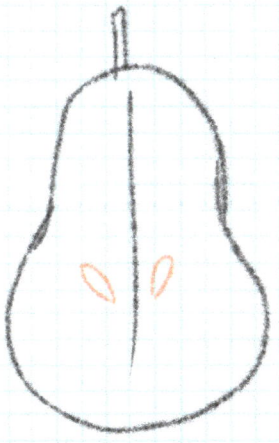

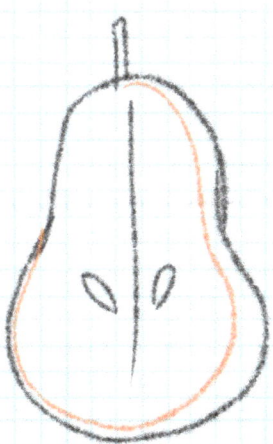

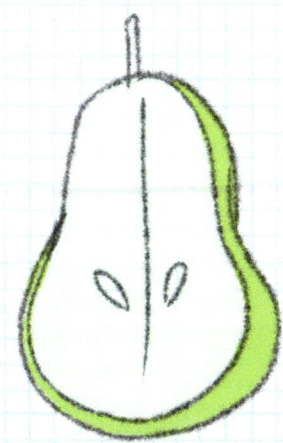

3. ADD A PAIR OF SEEDS IN THE LOWER HALF.

4. TO SHOW THE PEAR SLIGHTLY TILTED SO WE CAN SEE SOME OF THE SKIN ON ONE SIDE, DRAW A LINE MIRRORING THE EDGE OF THE PEAR SHAPE BUT CLOSER TO THE CENTER OF THE PEAR. THE SPACE BETWEEN THE TWO LINES WILL BE THE SKIN.

5. ERASE YOUR PENCIL LINES. COLOR IN YOUR PEAR.

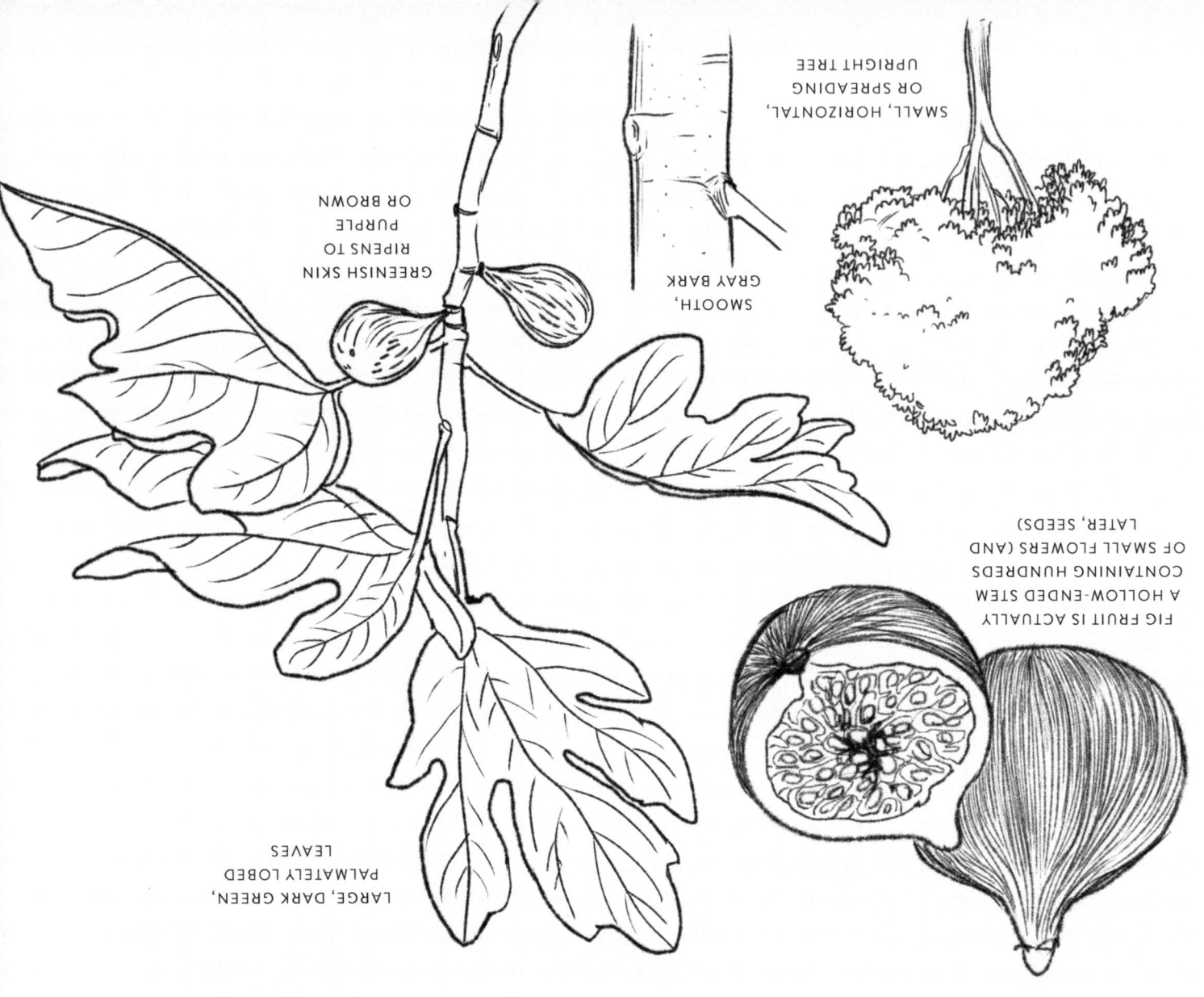

HOW TO DRAW FIGS
Ficus carica

- SMALL, HORIZONTAL, OR SPREADING UPRIGHT TREE
- SMOOTH, GRAY BARK
- GREENISH SKIN RIPENS TO PURPLE OR BROWN
- FIG FRUIT IS ACTUALLY A HOLLOW-ENDED STEM CONTAINING HUNDREDS OF SMALL FLOWERS (AND LATER, SEEDS)
- LARGE, DARK GREEN, PALMATELY LOBED LEAVES

1. START WITH A ROUND, TEARDROP OR PEAR SHAPE.

2. DRAW A CIRCLE INSIDE THE PEAR SHAPE. YOU'LL USE THE BOTTOM OF THE CIRCLE TO MAKE A SIDEWAYS CRESCENT MOON FOR THE FIG SKIN.

3. NOW DRAW A SQUIGGLY CIRCLE INSIDE THAT CIRCLE. LEAVE A LITTLE NOTCH NEAR THE TOP.

4. FILL THE SQUIGGLY CIRCLE WITH SEEDS, ALL POINTING TOWARD THE CENTER, WITH FEWER NEAR THE SIDES.

5. FILL IN THE SPACE AROUND THE SEEDS WITH SHORT, SQUIGGLY LINES, ALSO POINTING TOWARD THE MIDDLE.

6. ERASE PENCIL LINES AND COLOR THE OUTSIDE PURPLE AND THE INSIDE LIGHT YELLOW. THE SEEDS ARE YELLOW AND SET IN A REDDISH PINK COLOR.

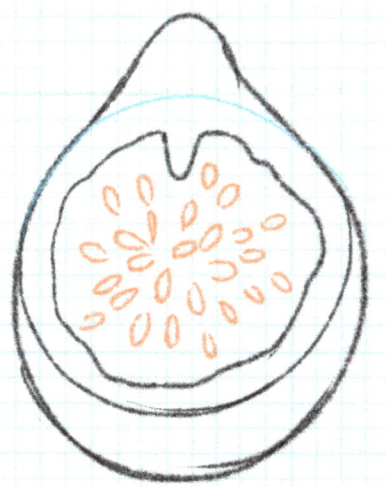
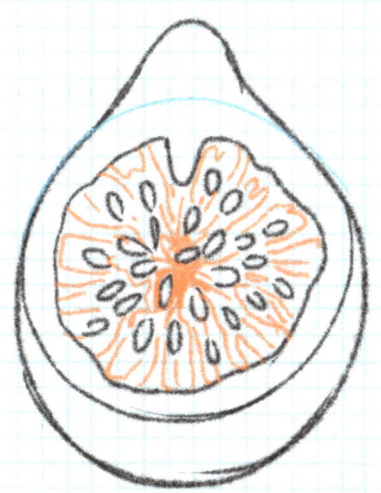
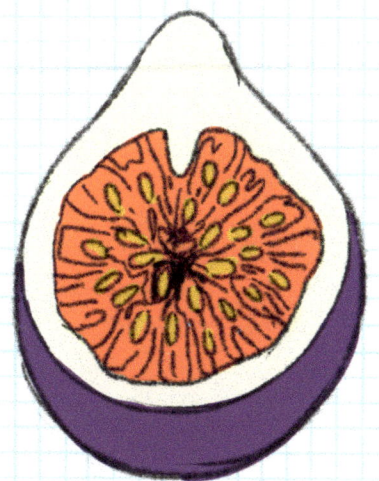

DRAWING TREES AND LEAVES | 81 | FORM AND FUNCTION

HOW TO DRAW PERSIMMONS
Diospyros kaki

1. START BY DRAWING A SLIGHTLY FLATTENED OVAL.

2. LET'S USE SOME GUIDES AND DRAW A PLUS SIGN OVER THE OVAL AND THEN DRAW TWO SMALL OVALS THAT CROSS IT LIKE A BULL'S-EYE.

3. DRAW A SMALL CIRCLE IN THE MIDDLE AND FOUR WIDE LEAVES WITHIN THE OVAL GUIDES. LET THE LEAVES OVERLAP.

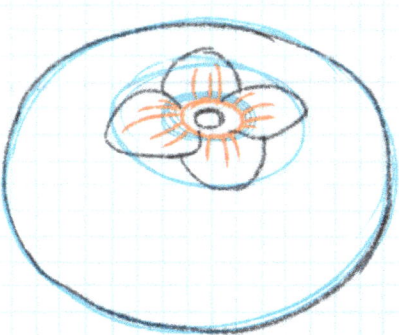

4. ADD DETAILS ON THE LEAVES RADIATING FROM THE CENTER.

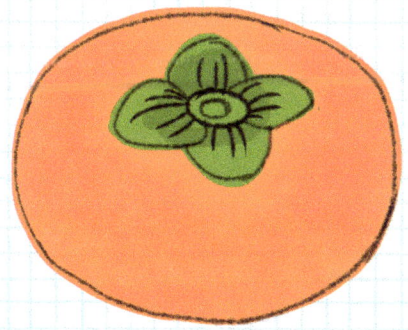

5. ERASE YOUR PENCIL LINES. COLOR THE FRUIT ORANGE AND THE LEAVES OLIVE GREEN.

DRAWING TREES AND LEAVES | 83 | FORM AND FUNCTION

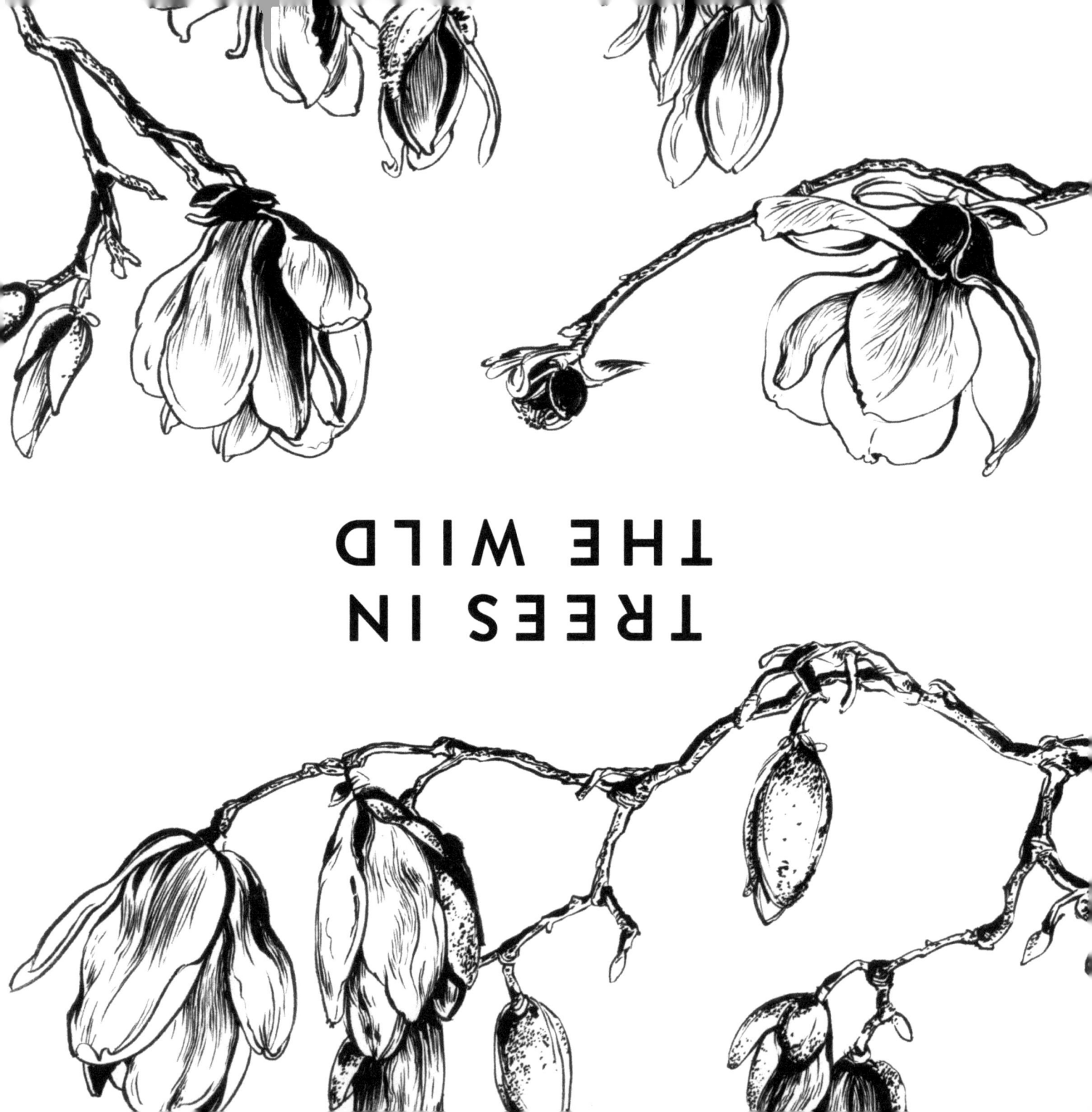

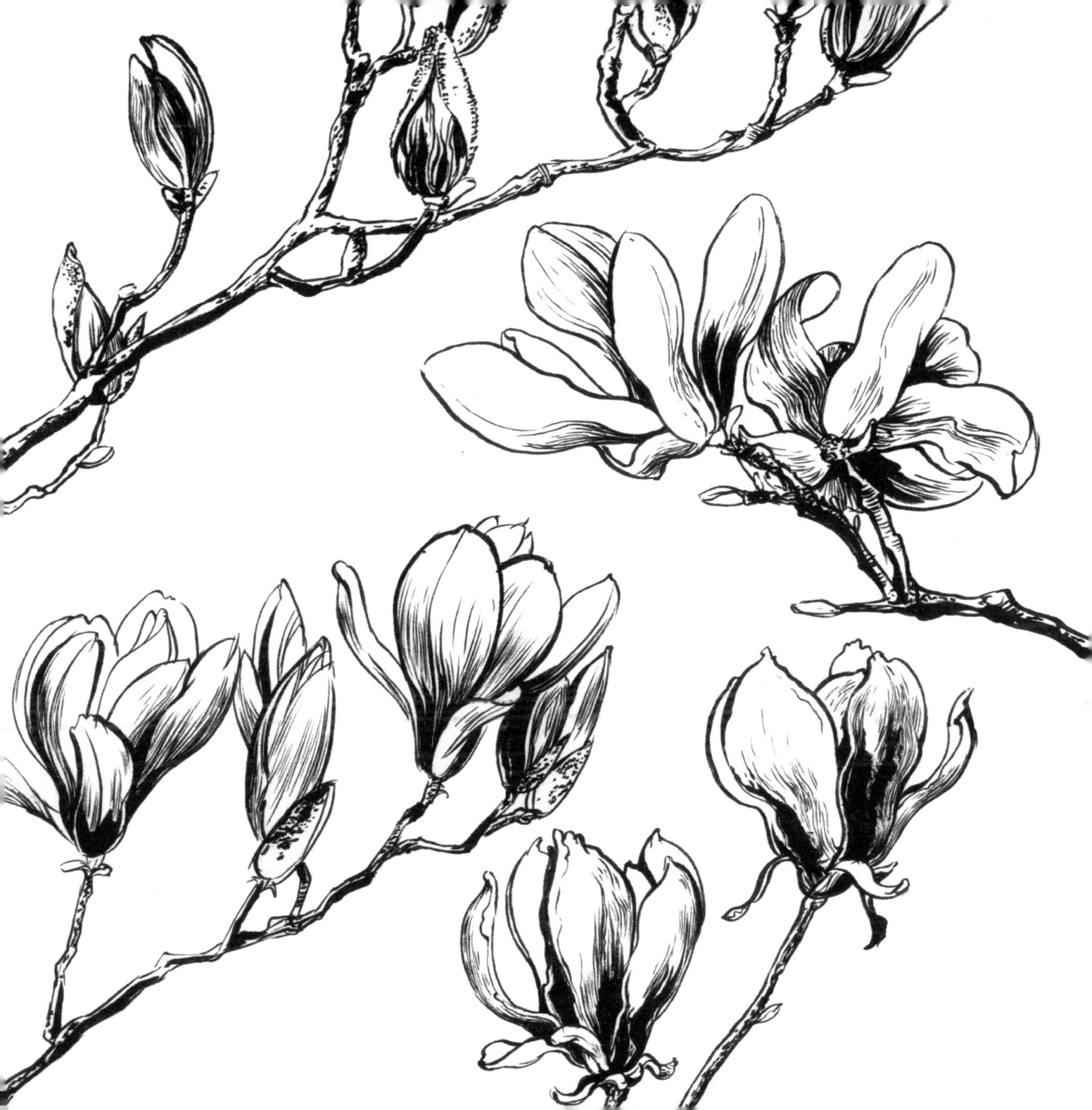

IDENTIFYING TREES

CURIOUS ARTIST TIP

When leaves have serrated edges, draw the overall leaf shape first, and then add the teeth. Remember that neither the shape nor the edges need to be perfectly symmetrical.

BLACK WALNUT LEAVES

LEAVES, BUDS, AND TWIGS

It can be hard to know where to start when trying to identify trees. A forest, or a stand of trees, can easily appear as a monochrome of green or a blur of browns and grays, where everything looks alike. By looking at the components of trees, however, their differences come into focus and we can begin to notice the characteristics of each species.

Leaves often draw our attention first. You might find leaves that are broad and flat or in the shape of needles or scales, such as those of spruce or cypress. Leaves might be single or compound, with a central stalk and a number of leaflets. Some leaves are divided by a series of lobes and notches, such as those of many maples and oaks. Closer inspection will reveal some leaves with smooth edges and others that are toothed in a variety of different styles. The pattern of their veins, and their general size, can also help differentiate leaves.

The characteristics of buds and twigs are also distinctive. The size, shape, and color of buds, as well their number of (or lack of) scales, are all useful clues. Twigs might grow straight or in more of a zigzag pattern, such as those of an American elm, and can be angular or rounded. Scars left on the twig when a leaf falls occur in specific shapes and patterns—the leaf scars on black walnut twigs resemble the face of a smiling monkey.

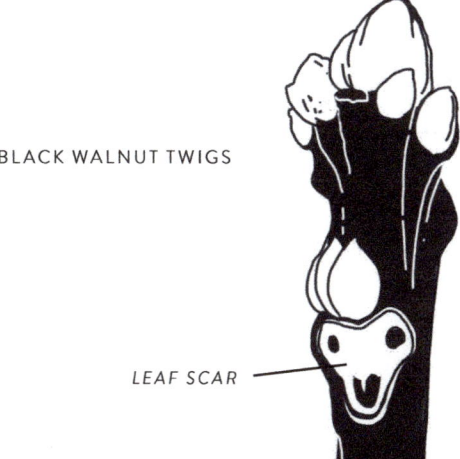

BLACK WALNUT TWIGS

LEAF SCAR

AN ABUNDANCE OF CHARACTERISTICS

When leaves are seasonally absent or when they, along with buds and twigs, are high up and hard to see on tall trees, other traits can help with species identification. Often it is a combination of characteristics that leads to the correct classification.

Leaves and twigs might grow opposite each other on the central stem, or they may alternate side to side. The silhouette of trees that grow in open space can also provide clues—American elm have a vaselike profile; the widespread branches of white oaks often appear gnarled and twisted. In general, forest trees competing with their neighbors grow narrower and more upright and have less iconic silhouettes.

Flowers and fruits, while they may be seasonal, are also distinguishing. Oaks can be differentiated by their acorns; in early spring, the many small, red flowers of red maples often stand out against the mostly bare branches of adjacent trees.

Bark is perhaps the most reliable tree characteristic—it is always visible, in any season. With a little practice, you can use the scales of spruce bark, the peeling bark of a birch or a eucalyptus, and other bark patterns to identify trees.

In addition to visual characteristics, trees offer clues for other senses. You can find black birch by the wintergreen smell and taste of its bark; feel the rough underside of a slippery elm leaf or the soft hairs on a sumac twig. On any individual tree, a seemingly limitless number of details are there to be noticed.

CURIOUS ARTISAT TIP

Notice that the enlarged dogwood leaf shows detailed veins throughout, while the branch of dogwood leaves shows only the midrib. We see more detail when we look at something up close, and we see less when it's further away, so try to do the same with drawing.

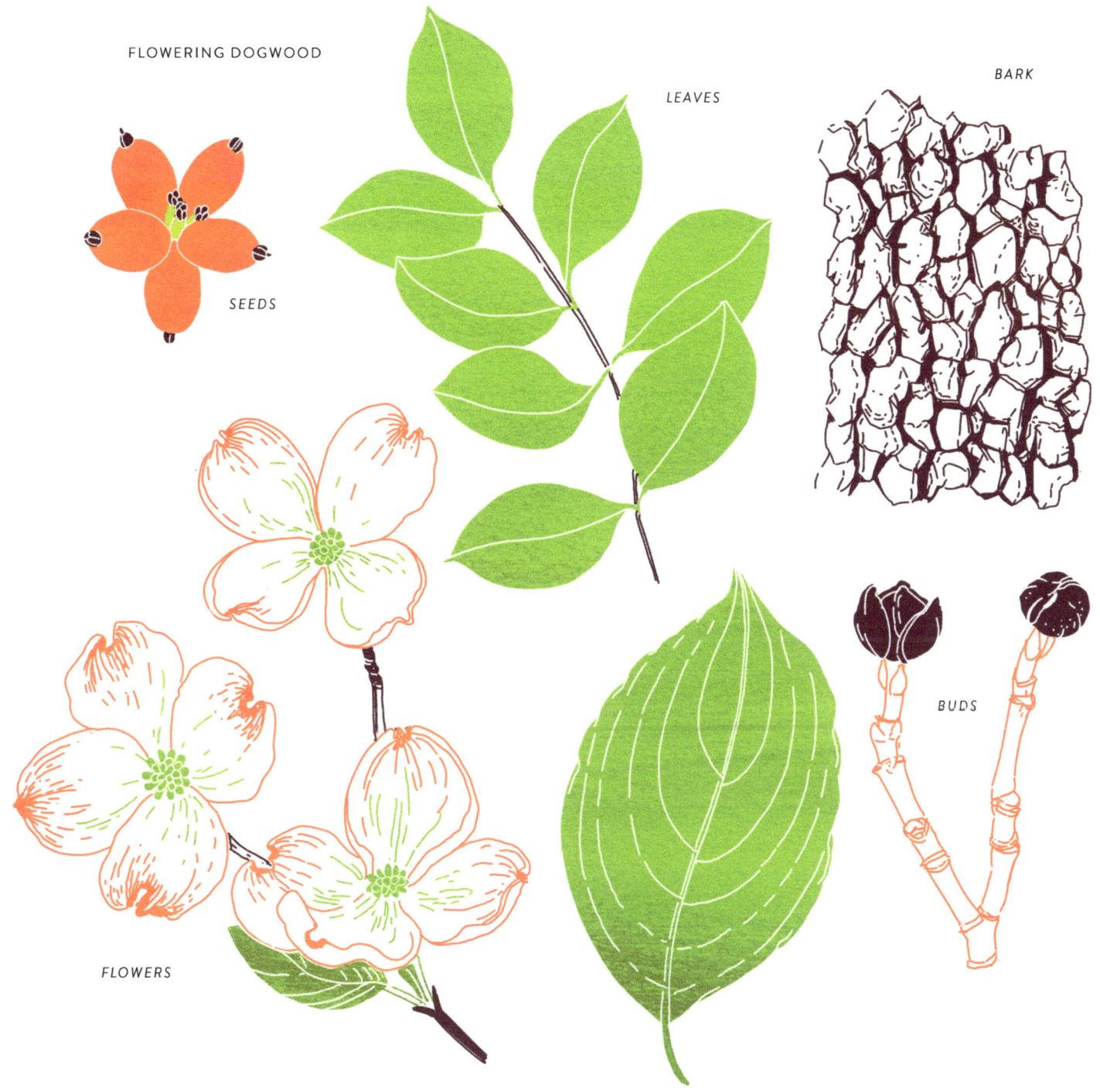

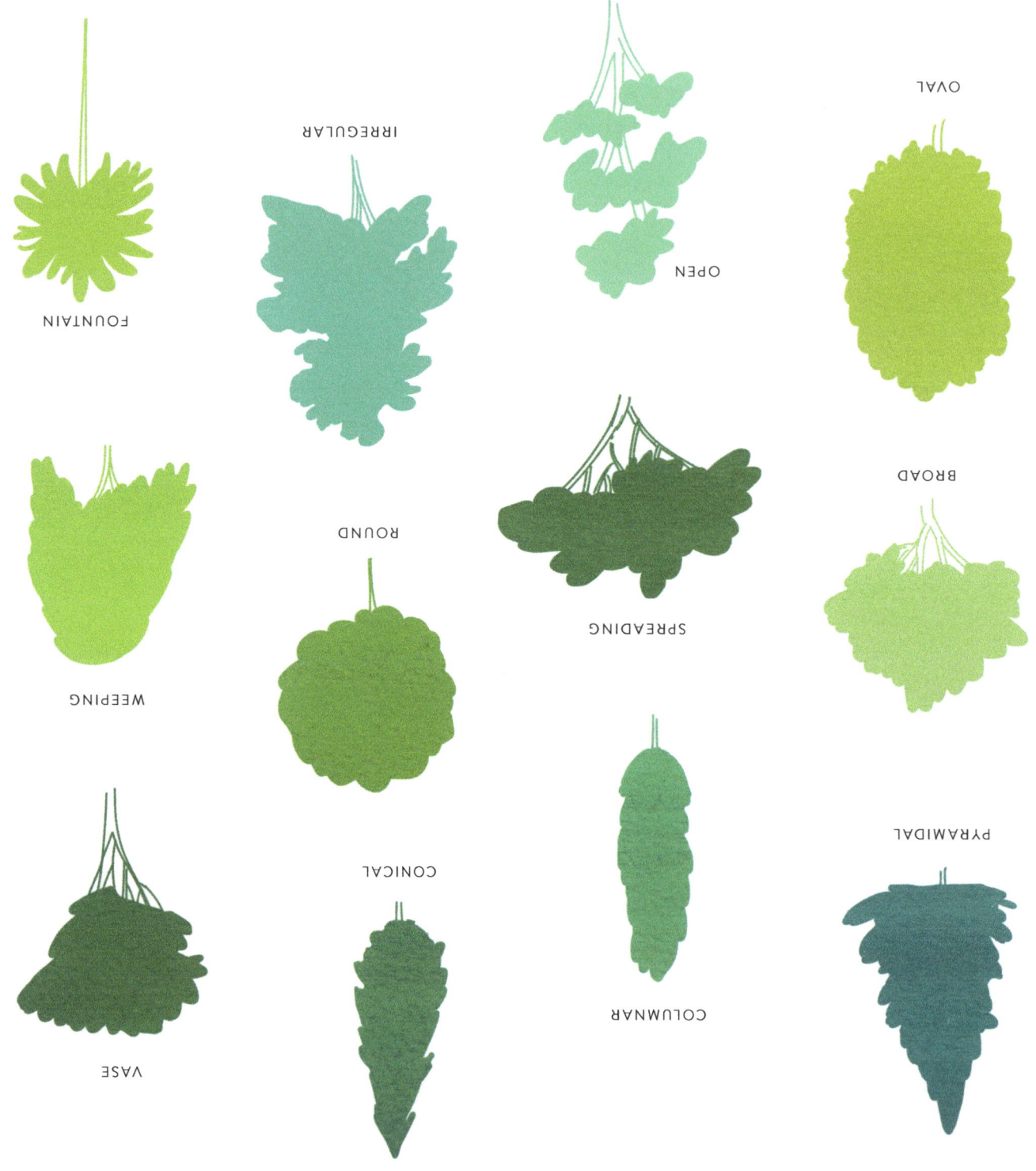

HOW TO DRAW BASIC TREE SHAPES

Try drawing some of the tree shapes shown above. Many trees resemble simpler shapes, so start there, and then add the trunk and branches. You can also start by tracing the outlines of a few trees to get a feel for their overall shapes.

1. TO DRAW A TREE WITH A BROAD SHAPE, START WITH AN IRREGULAR CIRCLE.

2. DRAW A TRUNK WITH TWO FORKING BRANCHES, LIKE TWO NESTED Vs.

3. ADD THREE OR FOUR SMALLER BRANCHES TO THE TWO MAIN ONES.

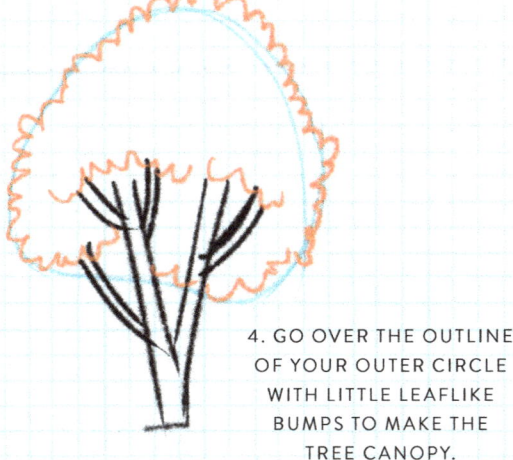

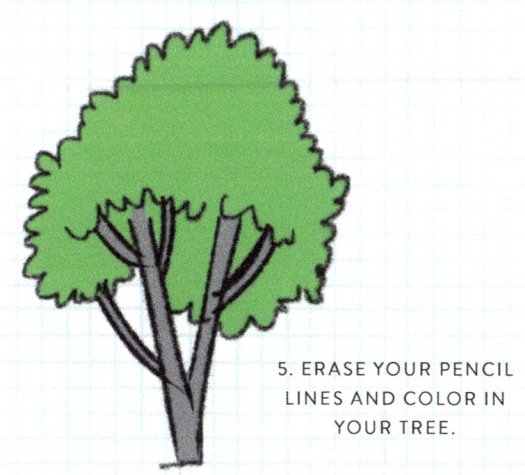

4. GO OVER THE OUTLINE OF YOUR OUTER CIRCLE WITH LITTLE LEAFLIKE BUMPS TO MAKE THE TREE CANOPY.

5. ERASE YOUR PENCIL LINES AND COLOR IN YOUR TREE.

DRAWING TREES AND LEAVES | 91 | TREES IN THE WILD

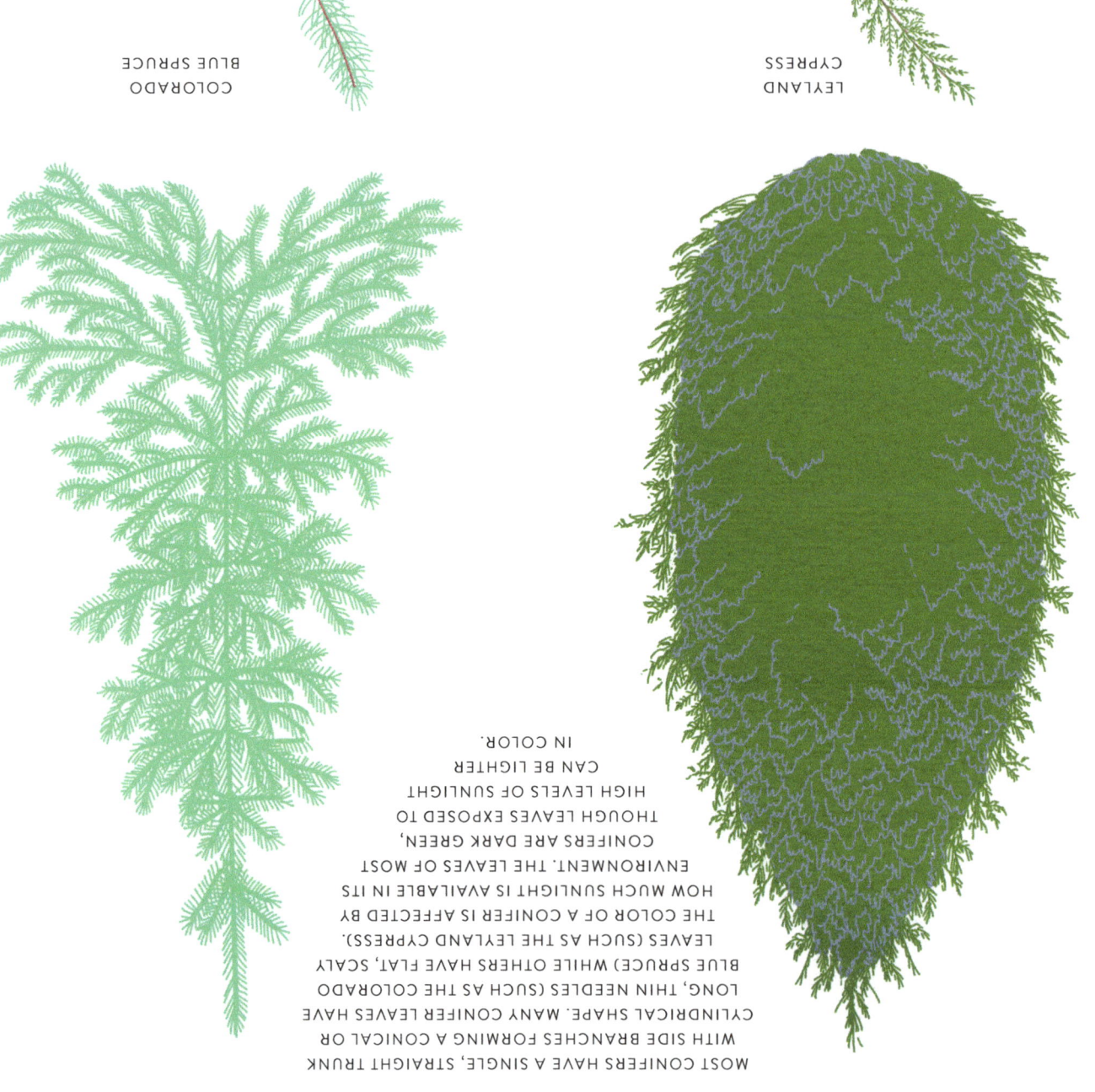

COLORADO BLUE SPRUCE

LEYLAND CYPRESS

MOST CONIFERS HAVE A SINGLE, STRAIGHT TRUNK WITH SIDE BRANCHES FORMING A CONICAL OR CYLINDRICAL SHAPE. MANY CONIFER LEAVES HAVE LONG, THIN NEEDLES (SUCH AS THE COLORADO BLUE SPRUCE) WHILE OTHERS HAVE FLAT, SCALY LEAVES (SUCH AS THE LEYLAND CYPRESS). THE COLOR OF A CONIFER IS AFFECTED BY HOW MUCH SUNLIGHT IS AVAILABLE IN ITS ENVIRONMENT. THE LEAVES OF MOST CONIFERS ARE DARK GREEN, THOUGH LEAVES EXPOSED TO HIGH LEVELS OF SUNLIGHT CAN BE LIGHTER IN COLOR.

HOW TO DRAW CONIFERS

1. TO DRAW A SPRUCE, START WITH A CONE SHAPE.

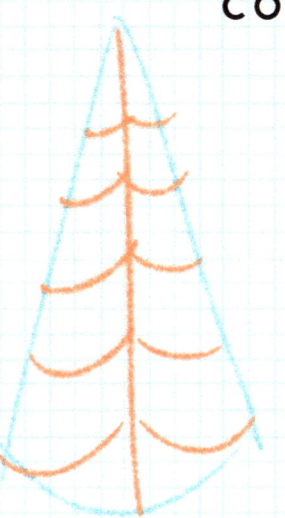

2. ADD A TRUNK DOWN THE MIDDLE AND SYMMETRICAL CURVED BRANCHES REACHING TO THE CONE'S SIDES.

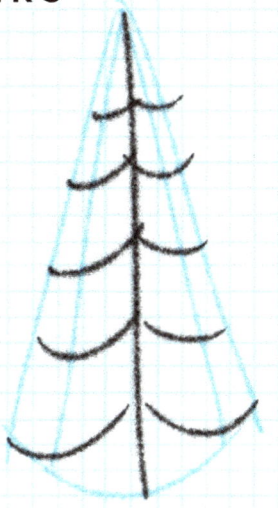

3. SKETCH A SMALLER CONE WITHIN THE BIGGER ONE.

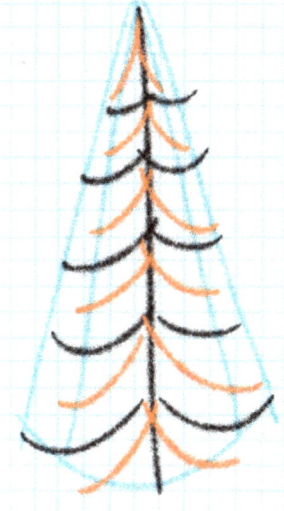

4. REPEAT BY ADDING BRANCHES, BUT LET THESE HANG DOWNWARD A BIT MORE.

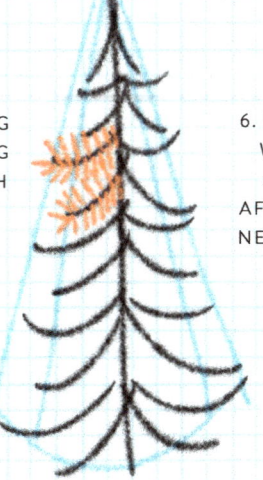

5. PRACTICE DRAWING THE NEEDLES COMING OFF A SMALL BRANCH AND THEN START ADDING NEEDLES TO EACH BRANCH OF YOUR TREE.

6. FILL IN THE TREE WITH NEEDLES, AND DON'T BE AFRAID TO LET THE NEEDLES OVERLAP.

7. ERASE YOUR PENCIL LINES.

HOW TO DRAW
WEEPING WILLOWS
Salix babylonica

HANGING LEAVES ARE NARROW, POINTED, AND LANCE SHAPED, DARK GREEN ON TOP AND LIGHT GREENISH GRAY BELOW

ROUGH, GRAYISH BROWN, DEEPLY FURROWED BARK

LIGHT BROWN FRUIT

MALE FLOWERS

BOTH TYPES OF FLOWERS ARE GREEN TO YELLOWISH CATKINS

BROAD, OPEN, IRREGULAR CROWN

FEMALE FLOWERS

DROOPING BRANCHES

MEDIUM TO LARGE TREE WITH A SHORT TRUNK

1. START OFF WITH A TRUNK AND A ROUND DOME. ALSO PRACTICE DRAWING LEAVES HANGING DOWNWARD OFF A BRANCH.

2. FILL THE DOME WITH SMALLER DOMES THAT GET SMALLER AS THEY GET CLOSER TO THE TOP.

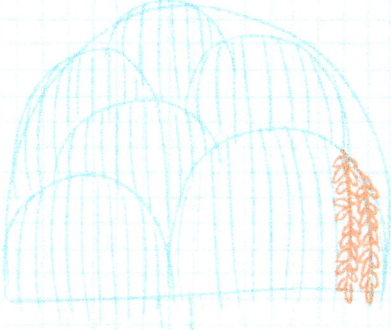
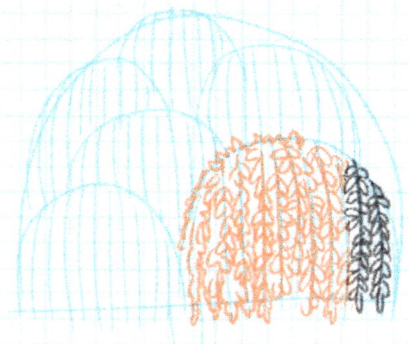

3. DRAW VERTICAL GUIDES FOR THE HANGING BRANCHES IN EACH SECTION.

4. DRAW DOWNWARD-HANGING LEAVES ALONG THE VERTICAL BRANCH GUIDES.

5. FILL ONE DOME SECTION THIS WAY.

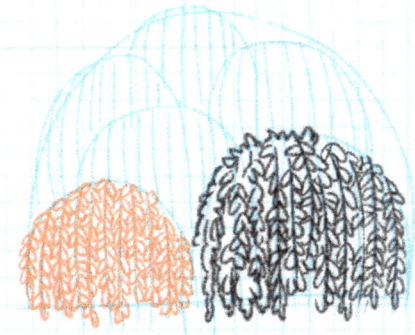
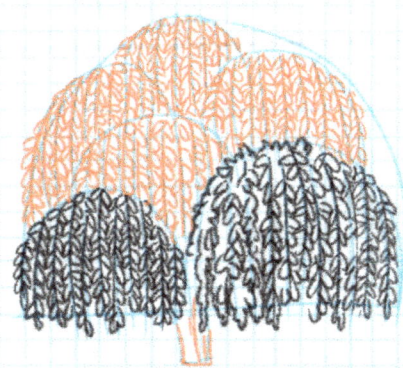
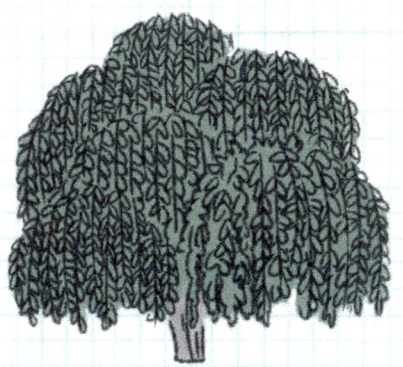

6. DO THE SAME IN ANOTHER SECTION. LET THE BRANCHES HANG UNEVENLY.

7. FILL IN ALL THE DOMES, AND DON'T FORGET THE TRUNK!

8. ERASE YOUR PENCIL LINES. COLOR THE TREE DARK GREEN AND THE TRUNK GRAY.

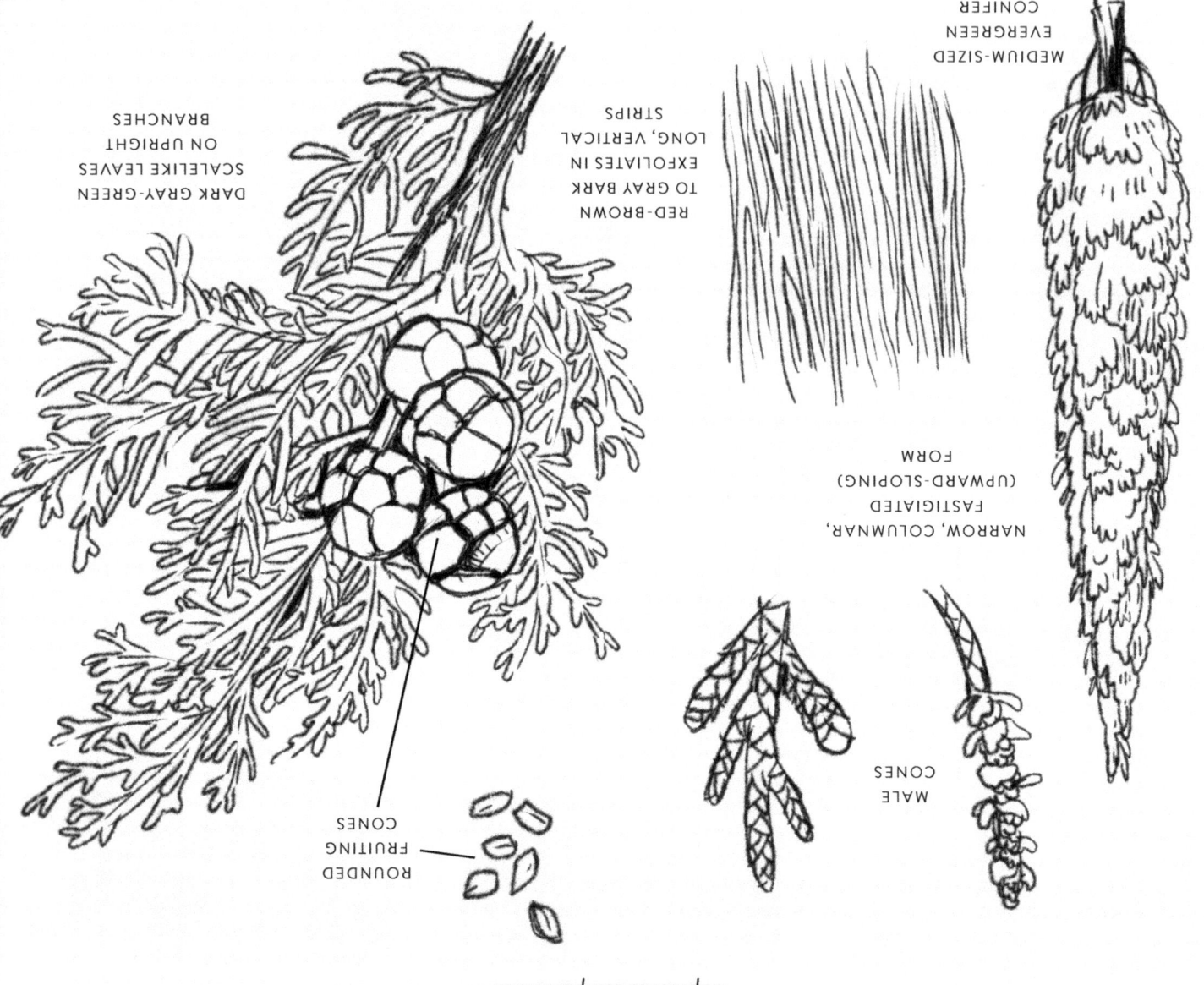

HOW TO DRAW
ITALIAN CYPRESS
Cupressus sempervirens

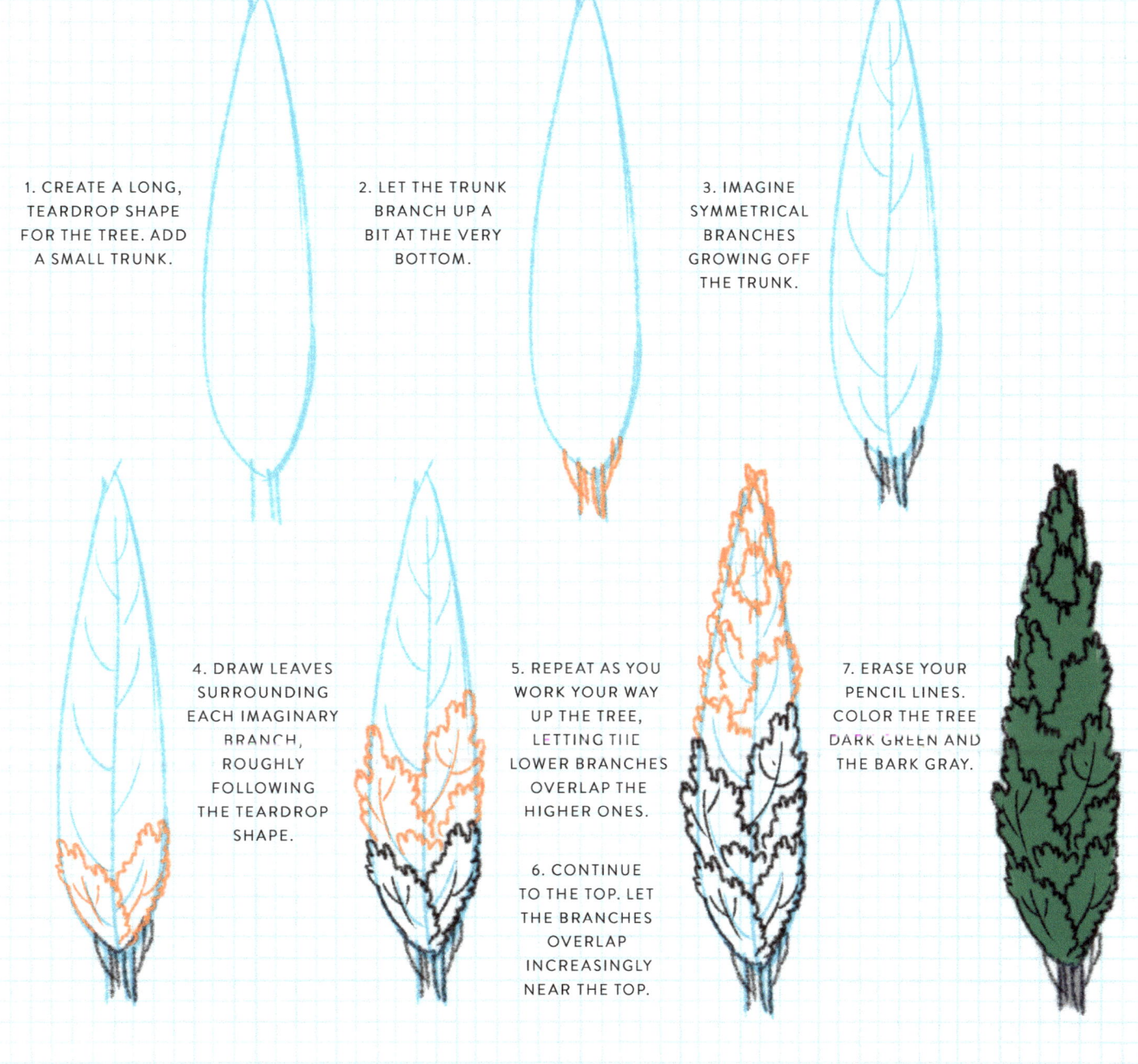

TREES AND OTHER ORGANISMS

SYMBIOTIC RELATIONSHIPS

Trees interact with a host of different organisms in what are referred to as symbiotic relationships, which might benefit, bring harm to, or have no real impact on the participants. Relationships can be as simple as a bird building a nest on the crotch of a branch—the bird and its family benefit, while the tree is neither harmed nor helped—or involve complex exchanges that can involve multiple organisms.

The relationships between trees and mycorrhizal fungi are less apparent. One might recognize these fungi by their reproductive structures—mushrooms such as truffles and chanterelles—but the majority of their growth occurs in the soil, where they form large networks of filaments called *hyphae*. When mycorrhizal fungi grow into a tree's root tips, they expand the reach of its root system. The tree receives water and nutrients, such as phosphorous and nitrogen, that they otherwise could not access, and the fungi get food from the tree.

DOUGLAS FIR SEEDLING

MATURE DOUGLAS FIR

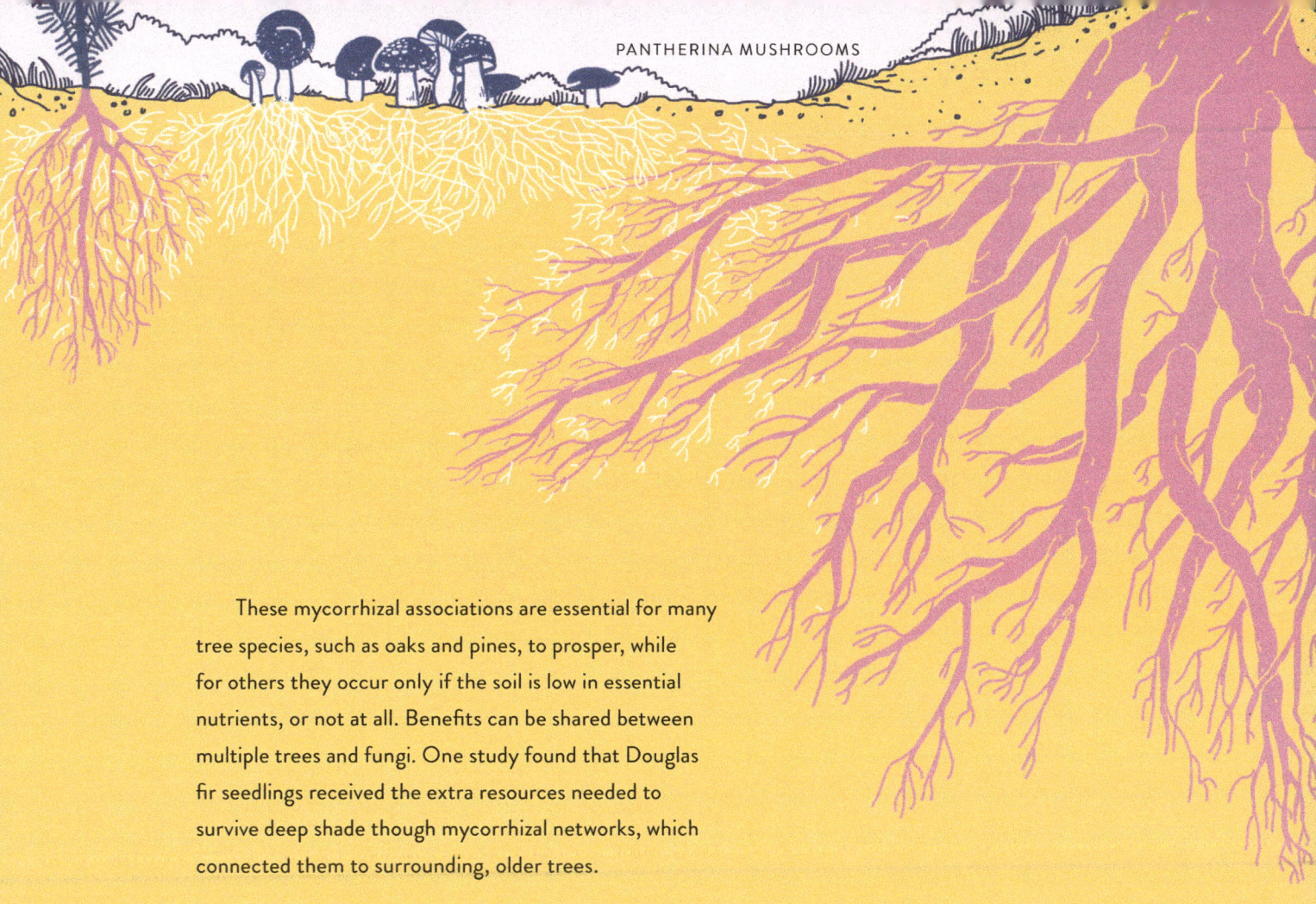

PANTHERINA MUSHROOMS

These mycorrhizal associations are essential for many tree species, such as oaks and pines, to prosper, while for others they occur only if the soil is low in essential nutrients, or not at all. Benefits can be shared between multiple trees and fungi. One study found that Douglas fir seedlings received the extra resources needed to survive deep shade though mycorrhizal networks, which connected them to surrounding, older trees.

CURIOUS ARTIST TIP | *When drawing root systems of neighboring plants, remember that they are never clearly divided. These root systems overlap and intertwine around rocks, other tree roots, and even their own roots.*

SILKY-FLYCATCHER

RED MAPLE

MISTLETOE

CHAINS OF ASSOCIATIONS

Hundreds of different species of parasitic plants, commonly referred to as mistletoe, grow on the branches of trees and extract water and minerals. Mistletoe can weaken, stunt the growth of, and kill trees, but for many birds and other animals, it provides important sources of food and shelter.

Moss, lichens, ferns, and other epiphytes are not parasitic; they use the trunks and branches of trees as a growing platform without extracting food or water. In tropical regions, epiphytes can amass in such volume that their collective weight breaks branches or topples whole trees, but in lesser densities they can bring some benefits. Trees receive a small nutritional boost when minerals and bits of organic matter from epiphytes are washed to the ground by rainwater and absorbed by their roots. When springtails and other tiny insects congregate to feed on epiphytes, they attract spiders and ants that help keep populations of defoliating caterpillars in check.

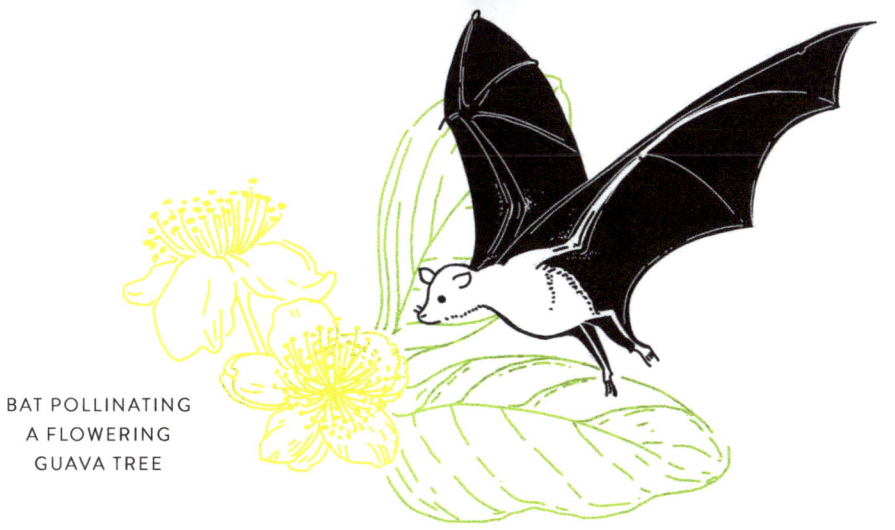

BAT POLLINATING
A FLOWERING
GUAVA TREE

Many tree species require mutually beneficial relationships with insects, hummingbirds, bats, and other pollinators to produce seeds. Some of these associations are highly specific—each species of fig tree is thought to rely almost exclusively on a different wasp species for pollination. Insects also damage and kill trees. Caterpillars defoliate them; beetles bore into their bark and wood to lay eggs, sometimes spreading the spores of harmful fungi in the process.

The multitude of symbiotic relationships between trees and other organisms reflects the complex and important role that trees play in the ecosystem.

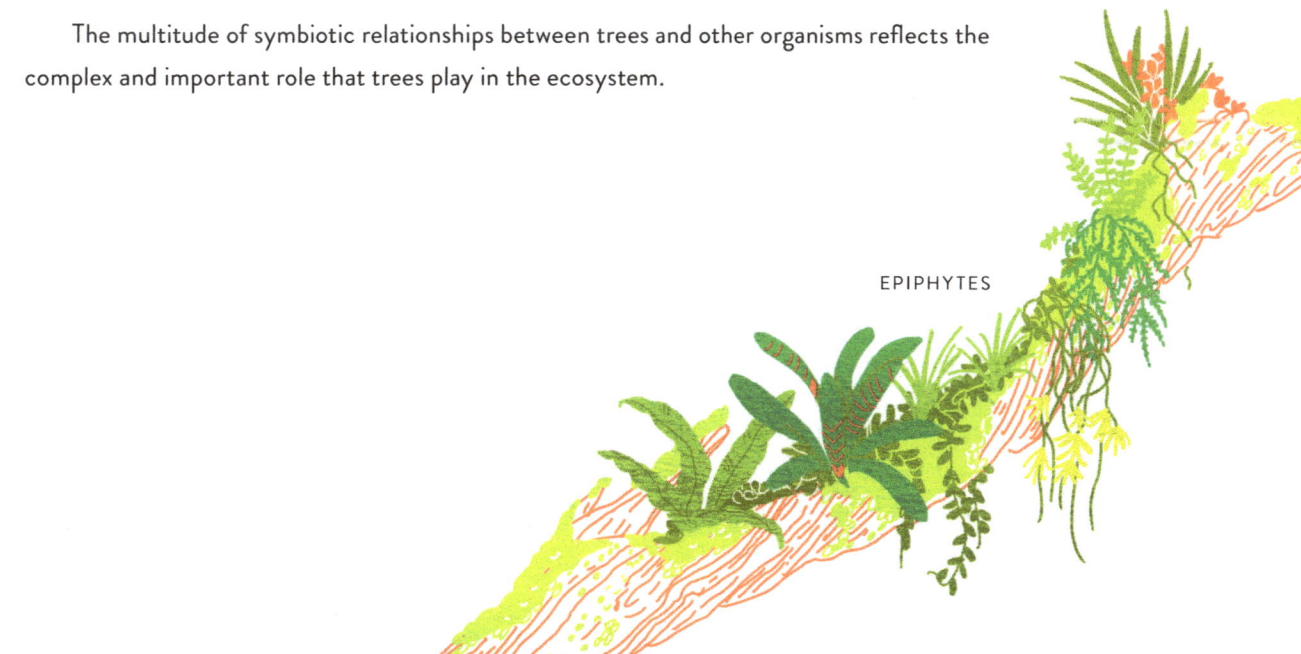

EPIPHYTES

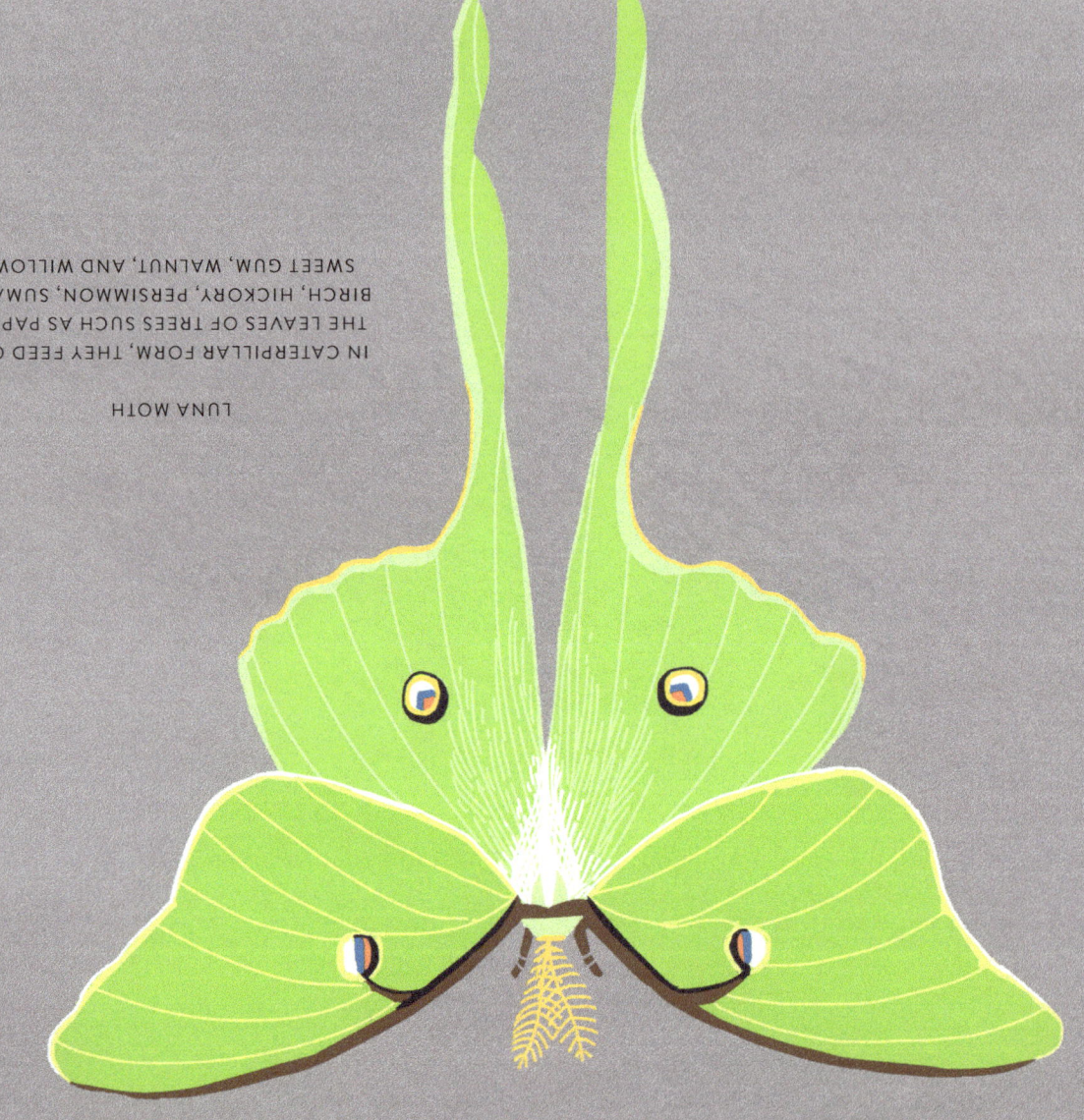

BUTTERFLIES AND MOTHS

LUNA MOTH

IN CATERPILLAR FORM, THEY FEED ON THE LEAVES OF TREES SUCH AS PAPER BIRCH, HICKORY, PERSIMMON, SUMAC, SWEET GUM, WALNUT, AND WILLOW.

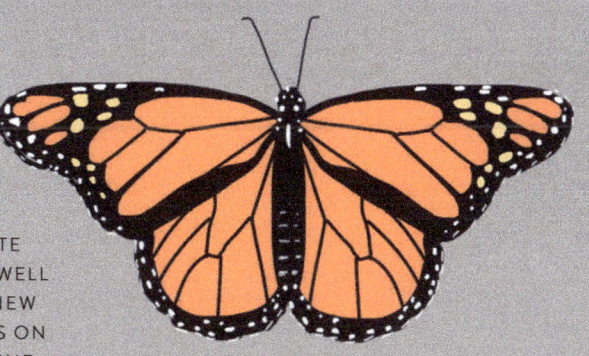

MONARCH BUTTERFLY

THESE BUTTERFLIES MIGRATE ACROSS NORTH AMERICA AS WELL AS WITHIN AUSTRALIA AND NEW ZEALAND. ROOSTING OCCURS ON TREES SUCH AS MONTEREY PINE, SYCAMORE, AND EUCALYPTUS.

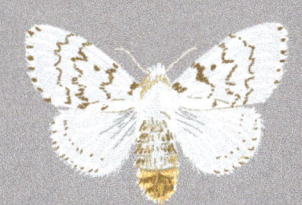

GYPSY MOTH

ORIGINALLY FROM EUROPE AND ASIA, THESE MOTHS ARE NOW SOME OF NORTH AMERICA'S MOST INVASIVE AND HARMFUL FOREST PESTS. THEY FEED ON THE LEAVES OF OAK, ASPEN, AND OTHER TREES.

WHITE ADMIRAL BUTTERFLY

ALSO CALLED THE RED-SPOTTED PURPLE, THIS IS A MIMIC OF THE POISONOUS PIPEVINE SWALLOWTAIL. THIS BUTTERFLY PREFERS TO FEED ON BIRCH AND POPLAR.

REGAL MOTH

THE REGAL MOTH IS ONE OF THE LARGEST MOTHS IN NORTH AMERICA. THE RAVENOUS CATERPILLAR FORM HAS LARGE RED AND BLACK HORNS, EARNING IT THE NAME "HICKORY HORNED DEVIL."

HOW TO DRAW
LUNA MOTHS
Actias luna

HOW TO DRAW
MONARCH BUTTERFLIES
Danaus plexippus

1. START WITH A DIAMOND FOR THE BODY.

2. DRAW A GUIDE FOR BOTH SETS OF WINGS USING THESE SIMPLE SHAPES.

3. OUTLINE THE WINGS AND BODY WITH THE CURVES IN THIS EXAMPLE.

4. DRAW A CIRCLE IN EACH WING.

1. START WITH A CAT'S-EYE SHAPE FOR THE BODY.

2. DRAW TWO SETS OF TRIANGLES ON EITHER SIDE.

3. ROUND OUT THE EDGES OF THE FOUR TRIANGLES TO CREATE THE WINGS.

4. OUTLINE THESE SHAPES AND ADD ANTENNAE.

5. DRAW A BORDER ALONG THE EDGE OF EACH WING.

5. FOLLOW THIS GUIDE TO DRAW SLIGHTLY CURVED LINES IN EACH WING.

6. ADD TWO FURRY ANTENNAE TO THE HEAD.

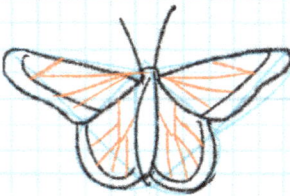

6. FOLLOWING THIS GUIDE, DRAW DIAGONAL LINES ACROSS THE WINGS.

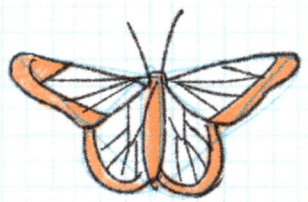

7. COLOR IN THE SECTIONS SHOWN IN RED WITH BLACK.

7. COLOR IN THE CIRCLES THIS WAY:

WHITE / RED / BLUE — TOP WINGS
RED / BLUE / WHITE — BOTTOM WINGS

8. FILL THE REST OF THE WINGS WITH ORANGE.

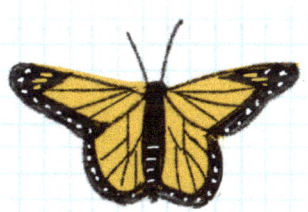

9. FINISH BY ADDING WHITE DOTS AROUND THE EDGES OF THE WINGS.

8. ERASE YOUR PENCIL LINES AND COLOR THE REST OF THE MOTH GREEN.

DRAWING TREES AND LEAVES | 105 | TREES IN THE WILD

THE WORLD'S OLDEST TREES

THE AGING TREE

One reason that trees can live longer than animals is that they are composed of modular systems—leaves, flowers, and branches can work independently of each other, and can be replaced if they are damaged or die. New leaves and new layers of wood and bark are added each year. An animal that has lost a foot or an eye can't just simply grow a new one. Age, however, does present problems for trees; unfortunately, they can't live forever.

As a tree ages, the surface area around its trunk and branches grows exponentially; more energy is required each year to produce a new layer of wood and bark around the outside of this ever-expanding supporting structure. Old trees reach a point where they struggle with, and eventually can't maintain, the food production and water supply that this increasing growth requires, as evidenced by the decreasing thickness of the growth rings in their wood.

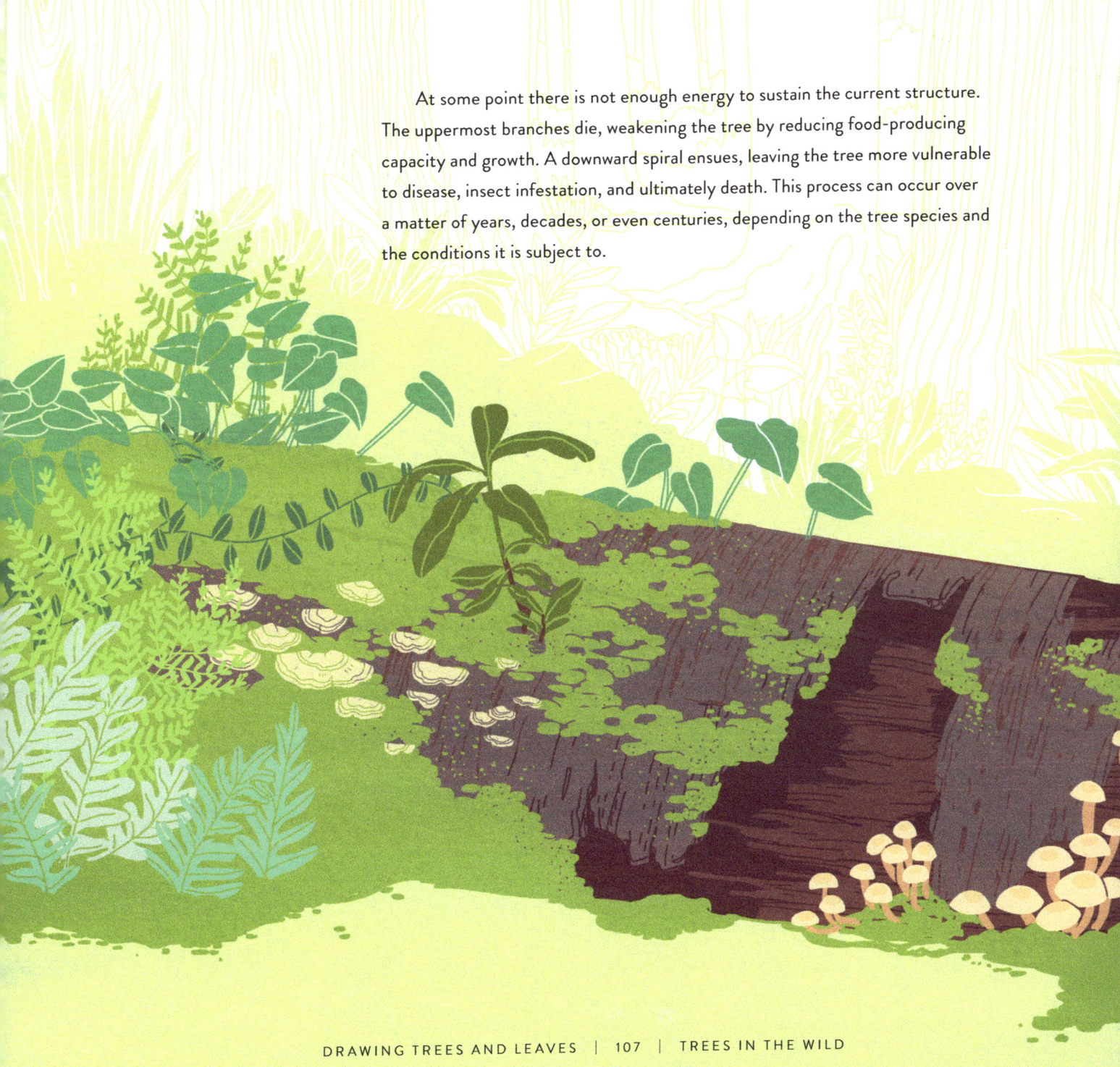

At some point there is not enough energy to sustain the current structure. The uppermost branches die, weakening the tree by reducing food-producing capacity and growth. A downward spiral ensues, leaving the tree more vulnerable to disease, insect infestation, and ultimately death. This process can occur over a matter of years, decades, or even centuries, depending on the tree species and the conditions it is subject to.

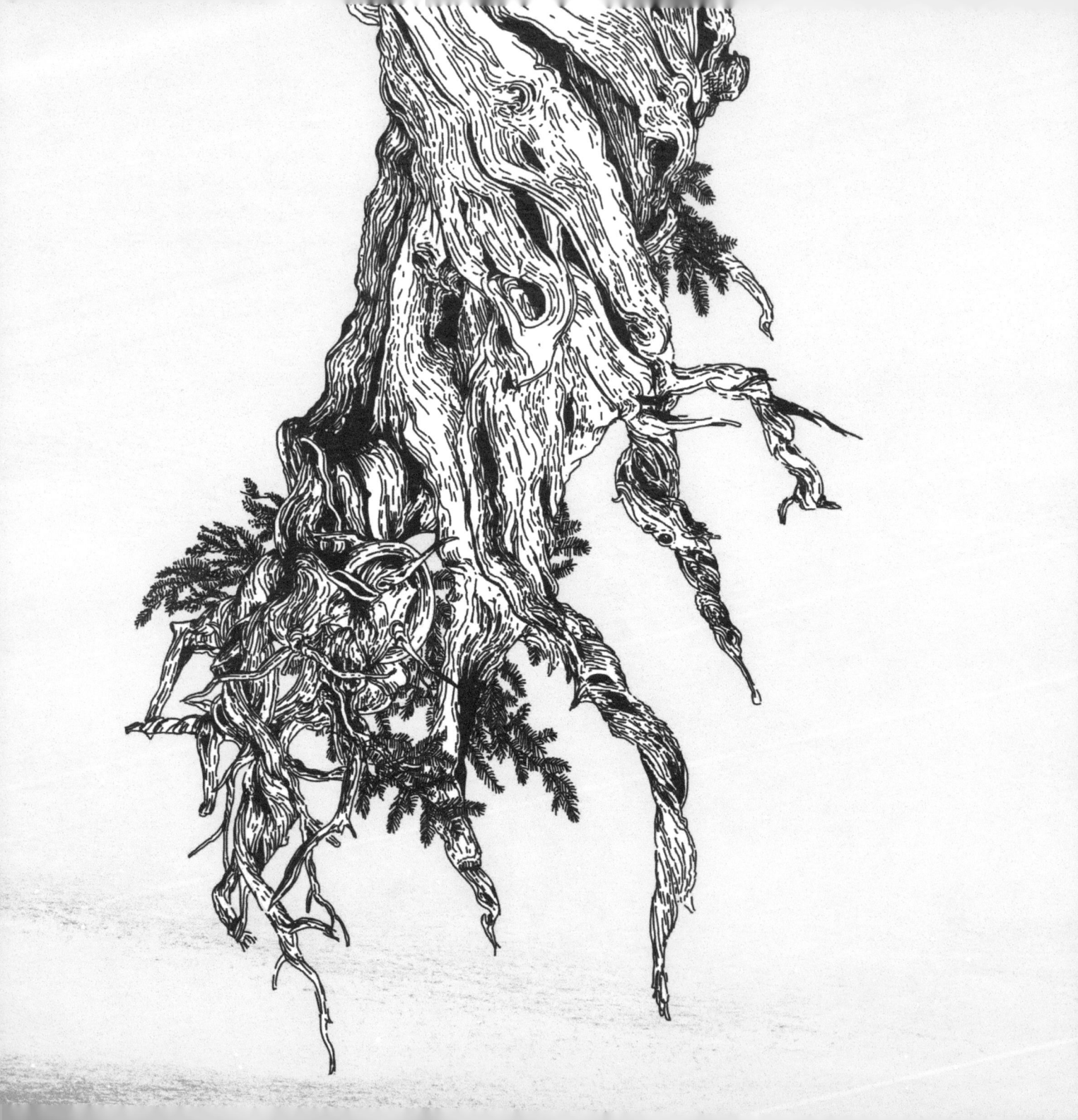

CHARISMATIC MEGAFLORA

The oldest verified living tree is a more than 5,000-year-old bristlecone pine that was already well established when the Egyptian pyramids were built. This tree and others of its species—at least two others are more than 4,800 years old—have survived in part because they grow so slowly. In their harsh, dry environment in California, they grow only over a matter of weeks each year. Their relatively smaller stature—the largest known bristlecone pine stands 41 ft (12.5 m)-tall—helps them weather the starvation, water deficits, and structural decline that come with aging.

A yew tree estimated to be between 4,000 and 5,000 years old grows in North Wales, and a Mediterranean cypress in Iran is at least 4,000 years old. The world's biggest individual trees are young by comparison and testify to the abundance of water and nutrients available where they grow in California. The biggest, as measured by volume, is a 275 ft (83.8 m)-tall sequoia estimated to be 2,300 to 2,700 years old. A coast redwood takes the prize of the tallest known tree, measuring at least 379.7 ft (115.7 m), and might be only 600 years old.

If we expand our view from individual trees to a colony, an 80,000-year-old grove of about 47,000 quaking aspen trees takes the longevity prize. Individually, the trees average about 130 years old, though they are genetically identical and share a vast, single root system that covers 106 acres (42 ha) in the western United States.

FAMOUS FORESTS

THE ALLURE OF FORESTS

Any single tree can capture our attention and, perhaps, our awe—we might notice a white oak's gracefully arched branches, the orange flash of an autumn maple leaf, or the camouflage bark of a sycamore. We might marvel at how an organism so big can make its own food or move water so high up from the ground. When all these trees grow together in a forest, the result is more than just the sum of notable traits. Things seem different within a forest—the quality of light, the feel of the air in our lungs, the clarity of sound. Perhaps, we sense the intricate processes within each tree and the web of interactions between trees and a vast array of different organisms.

People go out of their way to visit forests. Together, California's Giant Sequoia National Monument and Redwood National Park attract more than one million visitors a year. People often fall into awestruck silence upon mingling with the towering giant sequoias or coast redwoods there.

Forests do not need to harbor the biggest trees, or the oldest, to get our attention. In the dry, fire-prone pygmy pine plains of New Jersey, a miniature forest of trees ranging from 20 in (50 cm)- to 13 ft (4 m)-tall has long captivated the attention of many, including scientists curious about the mechanisms that limit their growth.

CURIOUS ARTIST TIP

Redwood trees tower above us. It would be a huge task to draw all the ridges in the many yards of bark; instead, you can draw hints of the ridges here and there to imply that they continue throughout the tree.

THE AVENUE OF THE BAOBABS

Baobab trees can be found in Madagascar, Africa, the Arabian Peninsula, and Australia. Baobabs have adapted to their harsh, arid environments by keeping water reserves in their trunks and shedding their leaves in dry seasons. This group of baobab trees was once a small part of a dense tropical forest in Madagascar. Now, they are the focus of local conservation efforts.

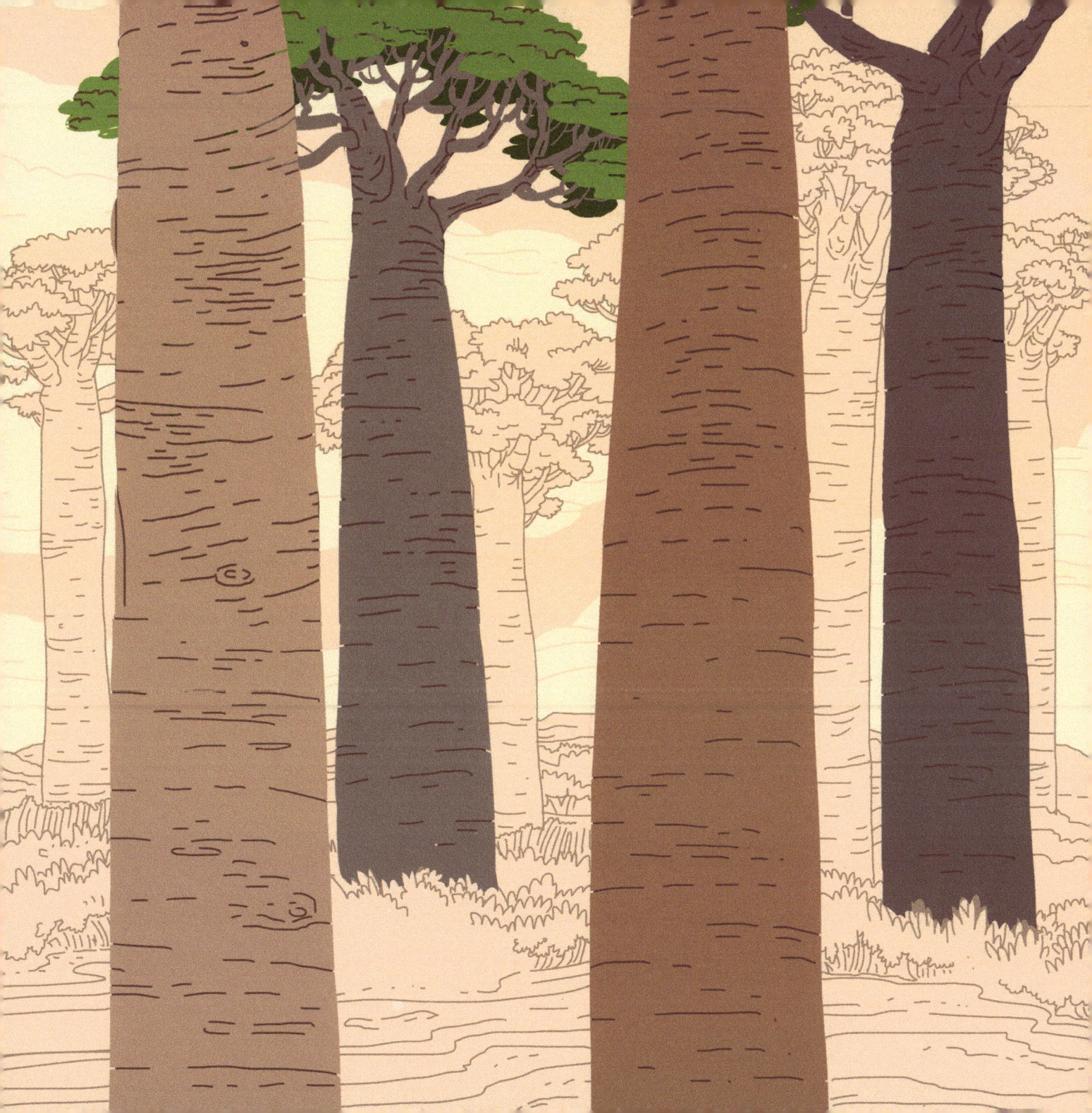

HOW TO DRAW
THE AVENUE OF THE BAOBABS
Adansonia grandidieri

1. DRAW A CYLINDER
FOR THE TRUNK.

2. AT THE TOP,
DRAW THREE SMALL
CYLINDERS FOR
BRANCHES.

3. DRAW THREE OR FOUR
SMALLER BRANCHES
COMING FROM THOSE
ORIGINAL BRANCHES.

4. ADD YET ANOTHER
LAYER OF VERY SMALL
BRANCHES COMING OUT
FROM THOSE BRANCHES.

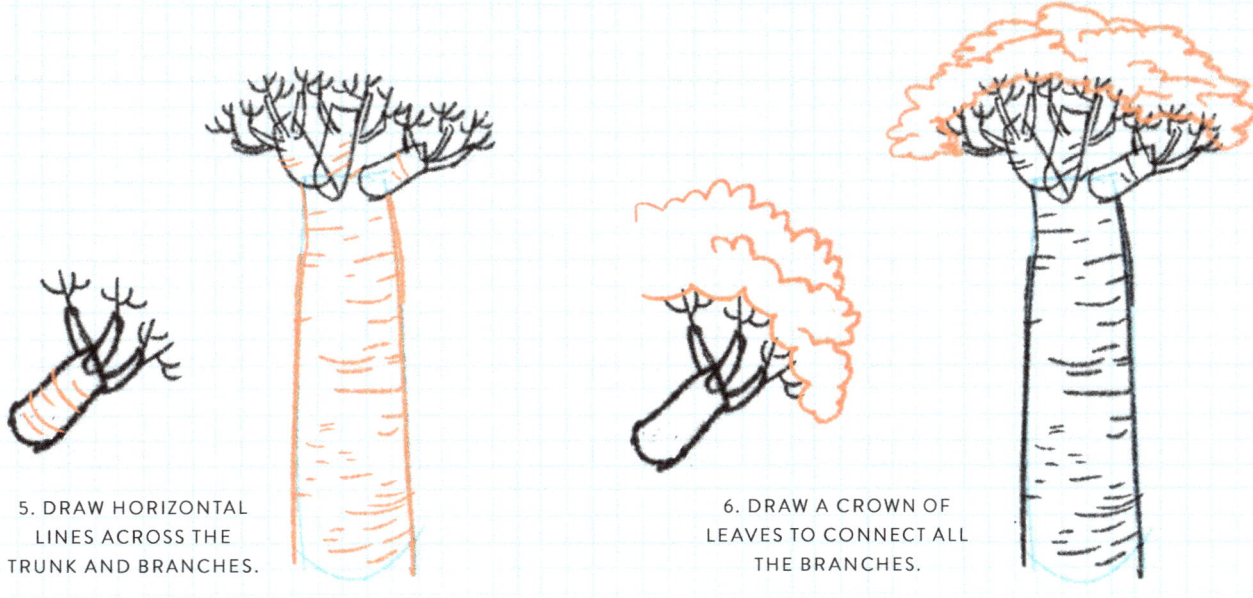

5. DRAW HORIZONTAL LINES ACROSS THE TRUNK AND BRANCHES.

6. DRAW A CROWN OF LEAVES TO CONNECT ALL THE BRANCHES.

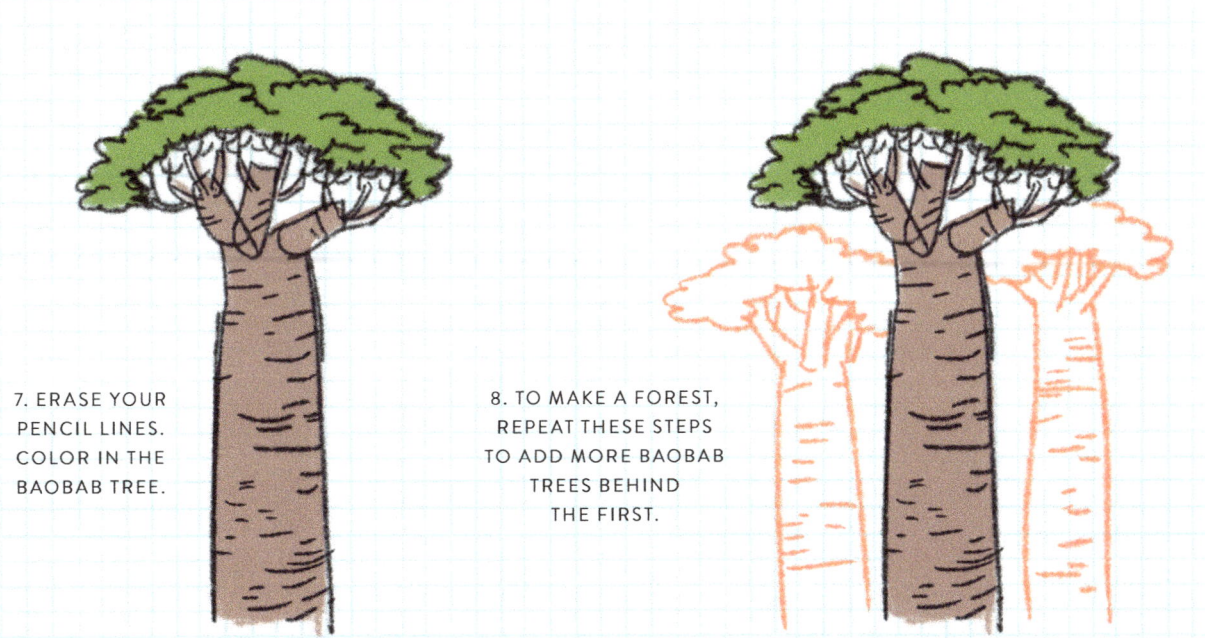

7. ERASE YOUR PENCIL LINES. COLOR IN THE BAOBAB TREE.

8. TO MAKE A FOREST, REPEAT THESE STEPS TO ADD MORE BAOBAB TREES BEHIND THE FIRST.

DRAWING TREES AND LEAVES | 115 | TREES IN THE WILD

SOMETHING FOR EVERYONE

The Black Forest in southwestern Germany is familiar to many, even those who have never set foot there. This region of dense, dark forests and picturesque villages inspired the settings for *Hansel and Gretel*, *Little Red Riding Hood*, and other traditional tales published by the Brothers Grimm, and it is a popular destination for recreation, relaxation, and rejuvenation.

Some forests are known for their great diversity of life. The Amazon Rainforest in South America is home to approximately 16,000 species of trees and thousands of other species, including toucans, giant tree sloths, piranha, and more than 2.5 million species of insects. Another place well known for its diversity is the Monteverde Cloud Forest Reserve in Costa Rica. This rare mountain forest, with a persistent low cloud cover, is home to a large number of species found nowhere else. It is believed that the Monteverde region has the highest diversity of orchids on Earth.

Autumn foliage brings thousands of people, often referred to as "leaf peepers," to the forests of New England—the northeastern region of the United States. The festival of colors begins with tinges of reds, yellows, and oranges in late summer and illuminates the region's forests as autumn progresses.

Forests all around the world, whether grand, exotic, or seemingly commonplace, are filled with attractions deserving of our attention and are worth a visit.

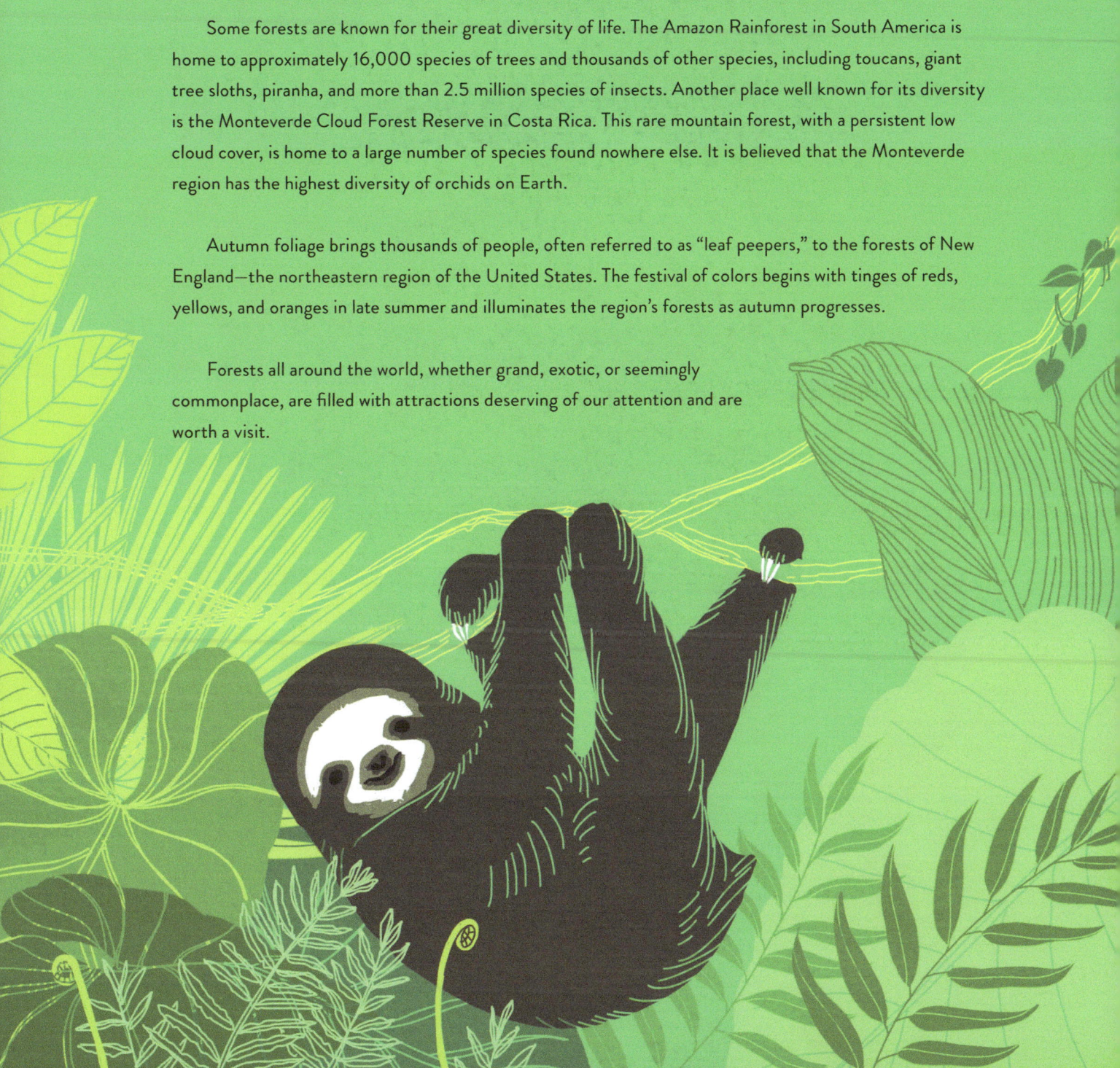

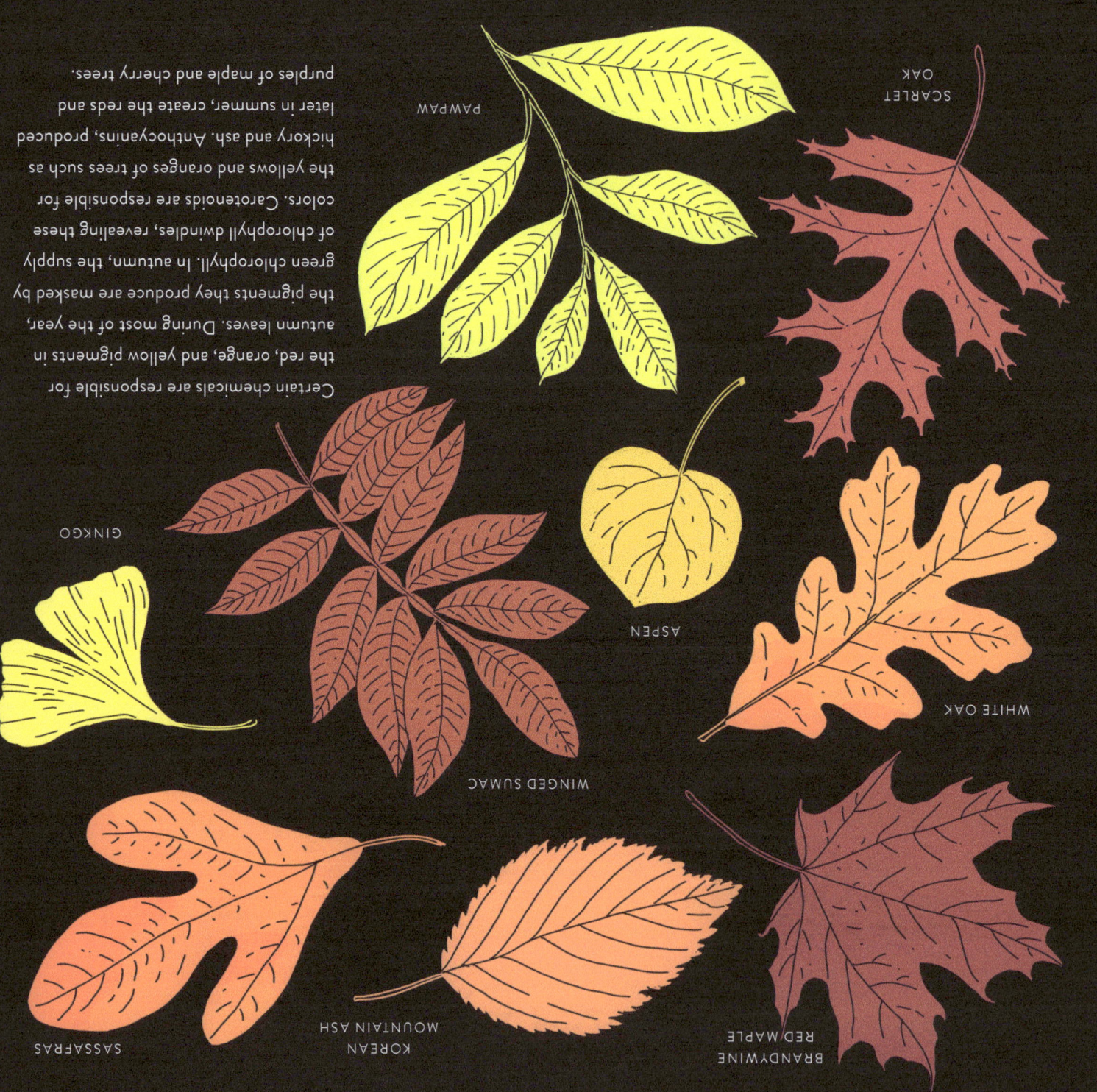

HOW TO DRAW
OAK LEAVES IN AUTUMN
Quercus alba

1. START BY DRAWING A TEARDROP WITH A STEM THROUGH ITS CENTER. DRAW A COUPLE OF Vs THAT INTERSECT THE STEM.

2. MAKE A LOOSE OUTLINE THAT SURROUNDS THE Vs AND THE TEARDROP SHAPE.

3. GO OVER THAT OUTLINE, ADDING A COUPLE OF ROUNDED LOBES TO EACH CURVE.

4. REDRAW THE STEM SYMMETRICALLY, BRANCHING OUT INTO EACH OF THE LOBES.

5. ADD A COUPLE OF VEINS COMING OFF THOSE LINES.

6. ERASE YOUR PENCIL LINES. USE YOUR FALL COLOR OF CHOICE.

DRAWING TREES AND LEAVES | 119 | TREES IN THE WILD

THE BENEFITS OF TREES

ECOSYSTEM SERVICES

Perhaps none of the benefits of trees is more important than ecosystem services—the functions by which they help create and sustain the environment that we and a host of animals, plants, and other organisms live in. We need look no further than the air around us. During photosynthesis, trees release life-sustaining oxygen—one tree can produce enough to support ten people for a year—and they also absorb and store carbon dioxide. The maintenance and restoration of forests is a major strategy in our efforts to reduce atmospheric carbon levels and mitigate global climate change. Trees also improve local air quality by absorbing and trapping other airborne pollutants such as ozone and carbon monoxide.

Trees also impact climate by blocking wind, creating shade, and increasing humidity levels. Areas with greater tree cover experience lower temperatures, and the shade of even a single tree can provide a cool respite on a hot day. The large quantities of water vapor released into the air by forests have a cooling effect and can also influence rainfall patterns.

Trees and forests help form soils and maintain fertility, and they play a major role in filtering and maintaining healthy water supplies. Deforested watersheds can lose their ability to capture and store water, resulting in flooding, erosion, and, in some cases, desertification of the landscape.

CACAO TREE

CURIOUS ARTIST TIP

These football-shaped cacao pods hang off branches with the tips pointing toward the ground. Draw them scattered throughout the tree, especially toward the trunk and splitting branches.

CONNECTION, INSPIRATION, AND PRACTICAL USES

Trees and forests help us forge connections with and become rooted in the place we live. They foster serenity and mindfulness, and have been shown to help improve focus and concentration. Trees have long inspired creativity through art, literature, and architecture. Sacred trees and groves, such as Shinto and Buddhist groves in Japan and redwoods in North America, have been, and continue to be, important to many cultures around the world.

Trees provide us with an extensive array of products. We consume mangoes, apples, and other fruits; nuts such as cashews; and chocolate from the seeds of cacao trees. From tea leaves, we brew the world's most popular drink, and we extract oils from olives and other parts of trees. Tree sap is boiled down to make syrup; resins and latex are used to make chewing gum.

In addition to feeding us, trees provide medicines that help us stay healthy. Quinine from cinchona trees is used to treat malaria; salicin, the precursor to synthetically produced aspirin, comes from the bark of trees in the willow family.

Wood is used as a major building material, to make paper, and to heat and cook. Tannins from bark preserve animal hides, and latex tapped from rubber trees has a host of uses. A list of the many diverse products that come from trees would go on and on.

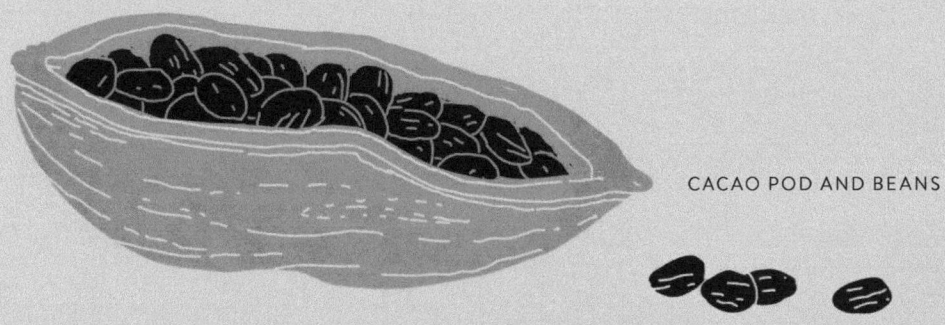

CACAO POD AND BEANS

PLANTING TREES

Harvesting trees yields a host of benefits to humans, including building materials, fuel, and open land for agriculture. As we better understand the wide-ranging benefits of living trees, efforts to preserve remaining forests around the world have increased, and many reforestation projects have been initiated.

A number of efforts are occurring in Brazil's Atlantic Rainforest. This forest harbors a level of diversity comparable to the Amazon Rainforest, although it is just a fraction of its size. In just a 2½-acre (1 ha) section (about one and a half soccer fields) researchers counted 458 tree species—more than twice the number in the eastern United States. The diversity of animals and other organisms in this forest is just as grand.

The Atlantic Rainforest once covered an area twice the size of France, but only 12 percent still remains. One project, an alliance of many different organizations, aims to reforest 2,400 acres (971 ha) and create a 37 mile (60 km)-long wildlife corridor that will connect two of Brazil's national parks. In addition to helping support biological diversity, this and other reforestation projects bring a broad range of benefits, such as increasing the available quantity and quality of water in the region, employing local residents to plant and maintain trees, and sequestering carbon to help mitigate climate change.

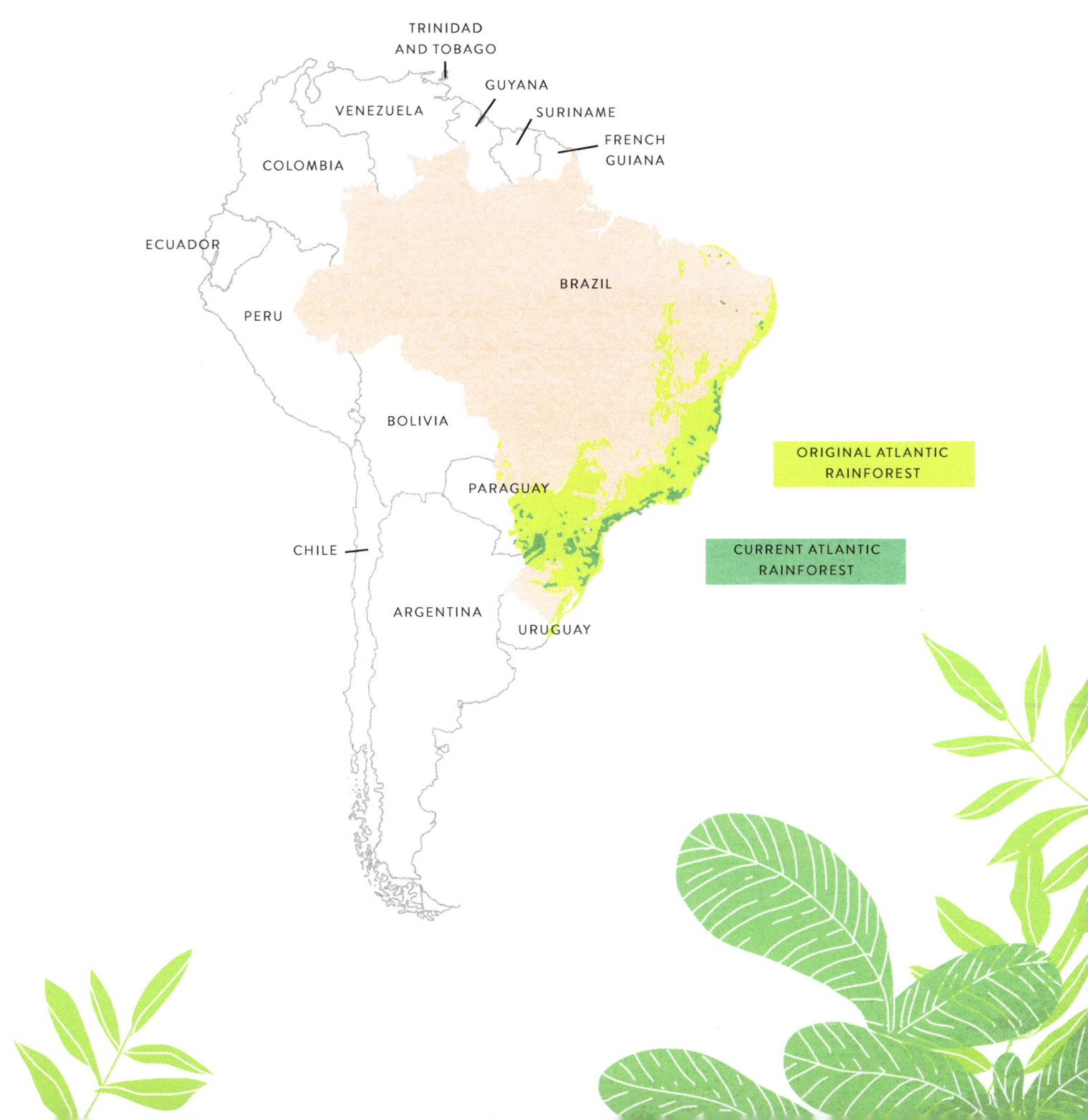

COMMUNITY EFFORTS

Reforestation projects often begin as local, grassroots efforts and can bring a wide range of benefits. One such project, the Green Belt Movement, was initiated by Nobel Peace Prize laureate Wangari Maathai in Kenya and later expanded to other African countries. Deforestation in Kenya has depleted the flow of many streams, degraded the soils, and impacted rainfall patterns, making it difficult for rural communities to grow food, find fuel for cooking and heating, and maintain their livelihoods.

Maathai helped small groups of women grow tree seedlings in cups, tin cans, or whatever containers were available. They nurtured the young trees until they were about 1 ft (30 cm)-tall, and then planted them. For the trees that survived, the women received a small payment that they could reinvest in their communities.

Over time, community tree nurseries and tree-planting programs were created in many Kenyan communities, and since the mid-1970s more than 51 million trees have been planted. Reforestation has helped restore local watersheds, allowing residents to again rely on the land for food, water, energy, and medicine and to reestablish their livelihoods.

Trees have been cultivated for thousands of years to produce food, oils, nuts, timber, and other products. Olive, date palm, fig, and pomegranate trees grown in the Fertile Crescent were among the first fruit trees to be domesticated. Reforestation efforts to develop timber resources in China occurred as early as the first century. In Japan, cherry trees have long been bred and planted for their blossoms.

The domestication of trees came after that of annual grains and other crops and required a different approach—the long-term dedication to a plot of land, watering, pruning, and in some cases tending to pollination. A newly planted orchard can take years to bear fruit. Trees for lumber mature over decades.

Orchards and other plots are frequently planted with a single or limited number of species, with a goal of harvesting consistent, uniform products from tree to tree. Because seeds produced through cross-pollination combine the genes of two parent trees and grow with a diversity of characteristics, many tree species are grown through vegetative reproductive techniques. Rooting twigs, transplanting suckers (root sprouts), and grafting twigs onto existing root stock ensure that desirable traits of a single parent tree are passed down to future generations. Golden Delicious apple trees, for example, are descendants of a single tree that was long ago selected for its fruit and other qualities.

WHY WE LOVE TREES

We have long been attracted to trees. They bring us great utility, be it food, timber, or other benefits. Children love to climb trees or hang a swing from their branches. We gather in their shade and plant them to commemorate a new birth or to memorialize a death. We celebrate trees in myriad ways.

Though trees that live for thousands of years, or soar many feet (meters) into the sky, inspire us with their vigor, we notice more than just the most useful, the oldest, or the biggest. We are also drawn to beauty—the graceful arc of bare branches, the slow eruption of new, tender leaves from buds, and the bloom of blossoms. Perhaps we also sense the less visible methods in which trees and forests function and support the ecosystems where they grow. The ways that trees draw water up from the ground to their leaves, provide oxygen for us to breathe, influence climate, and survive against a host of competitors and threats are beautiful in themselves. The more details we learn about trees, the more fascinating they become.

CURIOUS ARTIST TIP | *When drawing tree blossoms, remember that the tree's leaves are often in their early stages of growth. They will probably be much smaller in size and even in the process of unfurling.*

THE WISDOM AND LIFE OF TREES

Our deep connection with trees is ancient and woven into the world's mythology, culture, and art. Trees are often associated with wisdom and life. Evergreen trees and their branches are thought to have symbolized eternal life for ancient Egyptians, Chinese, and Hebrews, and today they represent part of Christmas traditions around the world.

In Japan, the brilliant, but brief, show of cherry blossoms each spring reflects the frailty and beauty of life, and is often the subject of literature, poetry, and art. The tree of knowledge from Jewish and Christian traditions grew in the Garden of Eden, where Adam and Eve ate its forbidden fruit.

Gautama Buddha reached enlightenment meditating under a sacred fig tree, which Buddhists call Bodhi, meaning "tree of knowledge." Hindus consider the sacred fig, often referred to as the peepal tree, as the tree of eternal life, with its roots in heaven and its branches spread on Earth. The broad, heart-shaped leaves of sacred figs, which grow on long, slender stems, rustle in imperceptible air currents—a trait attributed to the gods residing on them. Painting figures, scenes, and other images on these leaves, with their long, tapering tips, is an ancient tradition in India, and the branches of sacred figs are often depicted in graphic designs and sculptural friezes.

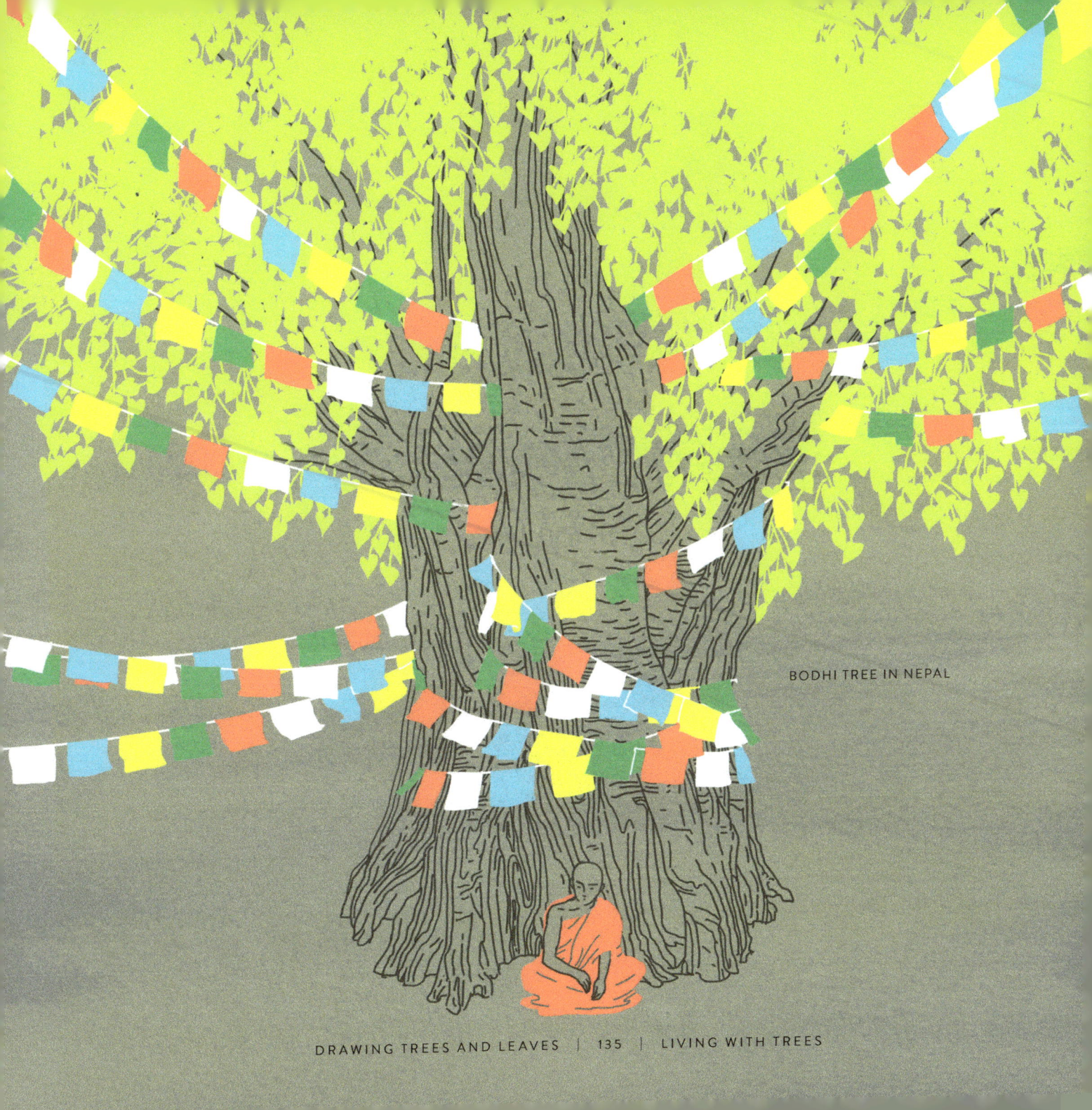
BODHI TREE IN NEPAL

BONSAI TREE STYLES

A bonsai is a tree with a mature appearance that is kept small enough to fit in a container. Bonsai are meant to replicate the proportions of full-grown trees, but rarely reach more than 3 ft (1 m) in height.

CHOKKAN
FORMAL UPRIGHT

THIS SYMMETRICAL, TRIANGULAR ARRANGEMENT IS CONSIDERED THE BASIS OF BONSAI FORMS. THIS BONSAI IS PRUNED AND WIRED TO GROW STRAIGHT UP, RESEMBLING A SITUATION IN NATURE WHERE THE TREE IS EXPOSED TO PLENTY OF LIGHT AND DOES NOT FACE COMPETITION FROM OTHER TREES.

MOYOGI
INFORMAL UPRIGHT

THIS POPULAR FORM IS MEANT TO RESEMBLE NATURE—IT GROWS BASICALLY UPRIGHT BUT WITH PROMINENT TWISTS AND CURVES. BRANCHING OCCURS AT EACH TURN, GROWING SMALLER NEAR THE TOP (SIMILAR TO THE CHOKKAN STYLE).

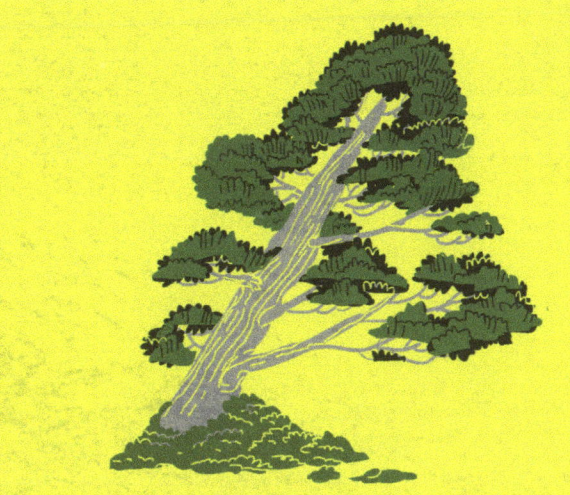

SHAKAN
SLANTING

THIS UNBALANCED BONSAI LEANS IN ONE DIRECTION, AS IF GROWING AWAY FROM THE WIND OR GROWING TOWARD THE SUN. THE TRUNK IS STILL STRAIGHT, BUT THE FIRST BRANCH AND ROOTS GROW IN THE OPPOSITE DIRECTION OF THE TRUNK TO CREATE BALANCE. BRANCHES GROW PARALLEL TO THE GROUND.

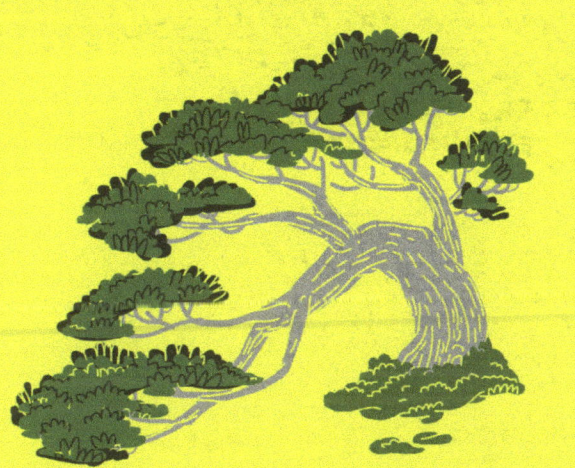

KENGAI
CASCADE

THIS STYLE IS MODELED AFTER TREES THAT OVERCOME DIFFICULT GROWING CONDITIONS (SUCH AS A SHEER CLIFF OR ROCKS) BY BENDING DOWNWARD BELOW THE ROOTS. THE TREE GROWS UPRIGHT FOR A SHORT STRETCH, THEN BENDS DOWNWARD. THE BRANCHES GROW OUT HORIZONTALLY TO MAINTAIN BALANCE.

HOW TO DRAW
MOYOGI BONSAI TREES

1. START WITH A
LOOSE, SQUIGGLY LINE.

2. ADD A SIMILAR LINE NEXT
TO IT TO CREATE THE TRUNK.

3. ADD FOUR OR FIVE THICK BRANCHES
WHERE THE CURVES ARE.

4. DRAW FOUR OR
FIVE LITTLE BRANCHES
FACING UPWARD FROM
EACH BRANCH.

5. CONNECT THESE SETS
OF SMALL BRANCHES WITH
SIMPLE, LEAFY BUBBLES.

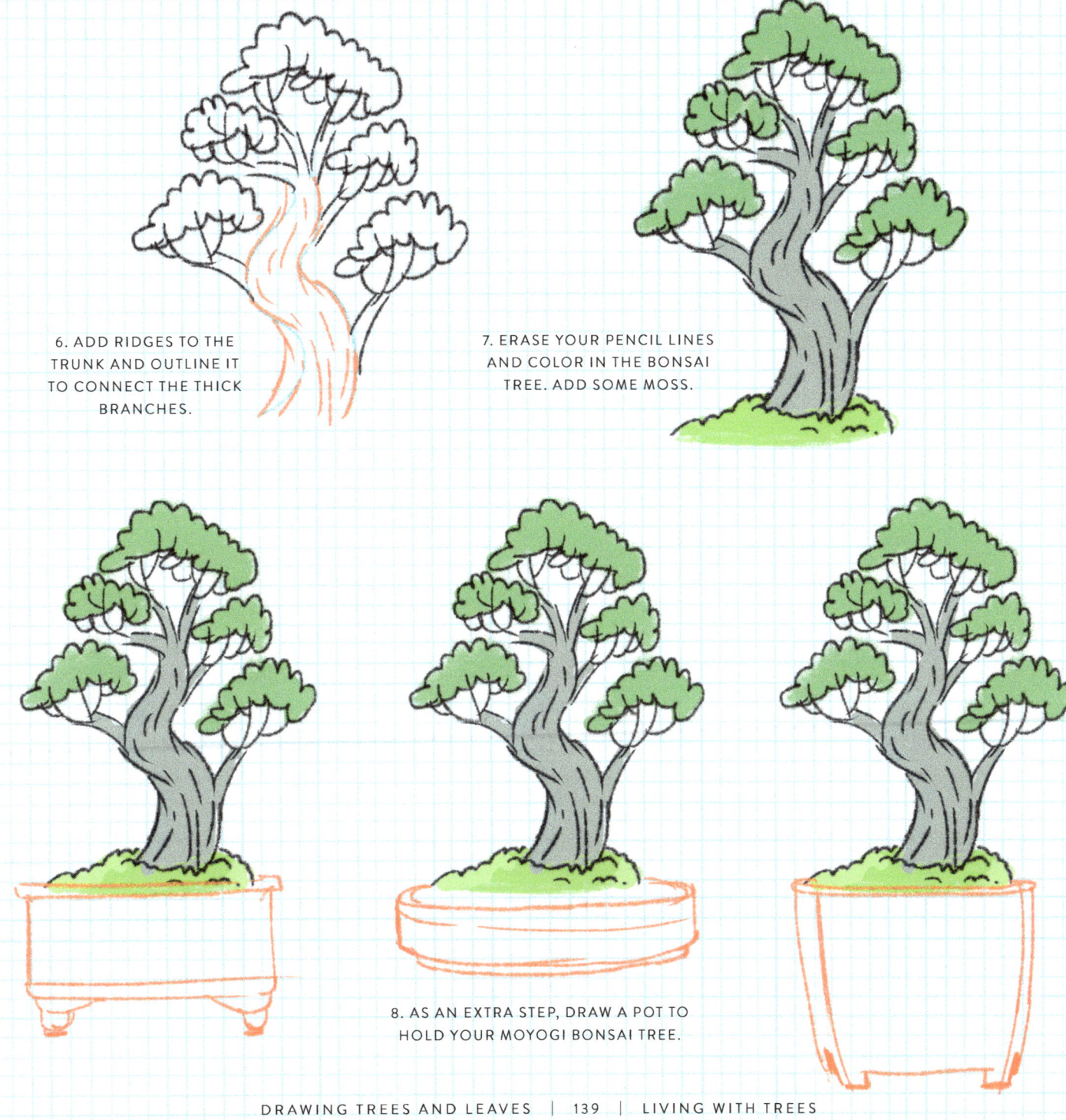

RESOURCES

PLACES, ORGANIZATIONS, PUBLICATIONS

We recommend the following for discovering, enjoying, and drawing trees and leaves. "The places to discover trees are countless, and include national, state, or local forests and parks, arboretums, nature centers, a small wooded parcel, or even the landscape where you live or work," Michael says. "When I'm outdoors studying or teaching, I usually don't need to go very far before I find an interesting tree to ponder. As you learn about and draw trees, you carry your most important resource with you—your curiosity and sense of wonder. Every encounter is an opportunity for new discoveries." Here is a list of resources we both find inspiring.

UNITED STATES AND CANADA

Acadia National Park | Bar Harbor, Maine
www.nps.gov/acad

The Arnold Arboretum of Harvard University | Boston
www.arboretum.harvard.edu

Banff National Park | Banff, Alberta
www.pc.gc.ca

Bryce Canyon National Park | Bryce, Utah
www.nps.gov/brca

Cary Institute of Ecosystem Studies | Millbrook, New York
www.caryinstitute.org

Cleveland Metroparks | Cleveland
www.clevelandmetroparks.com

Cuyahoga Valley National Park | Brecksville, Ohio
www.nps.gov/cuva

Denali National Park and Preserve | Denali Park, Alaska
www.nps.gov/dena

Forest Park | St. Louis
www.forestparkforever.org

Grand Teton National Park | Moose, Wyoming
www.nps.gov/grte

Harvard Forest | Petersham, Massachusetts
harvardforest.fas.harvard.edu

Kenai Fjords National Park | Seward, Alaska
www.nps.gov/kefj

Lincoln Park Conservatory | Chicago
www.chicagoparkdistrict.com/parks/lincoln-park-conservatory

Montrose Point Bird Sanctuary | Chicago
www.lakecookaudubon.org/Montrose_Point.html

The New York Botanical Garden | Bronx, New York
www.nybg.org

Shenandoah National Park | Luray, Virginia
www.nps.gov/shen

The Wild Center | Tupper Lake, New York
www.wildcenter.org

Yellowstone National Park | Wyoming
www.nps.gov/yell

Yosemite National Park | California
www.nps.gov/yose

Zion National Park | Springdale, Utah
www.nps.gov/zion

TAIWAN

Alishan National Scenic Area
www.ali-nsa.net

Kenting National Park
www.ktnp.gov.tw/eng

Shei-Pa National Park
www.spnp.gov.tw/v2/default.aspx?lang=1

Taipingshan National Forest
recreation.forest.gov.tw

Taroko National Park
www.taroko.gov.tw/English/

Yangmingshan National Park
english.ymsnp.gov.tw

PUBLICATIONS AND ORGANIZATIONS

American Forests
www.americanforests.org

Connecticut Botanical Society
www.ct-botanical-society.org

Eastern Native Tree Society (ENTS)
www.nativetreesociety.org

New England Wild Flower Society
www.newenglandwild.org

New York Flora Association
www.nyflora.org

Northern Forest Atlas Project
www.adirondackfoundation.org/funds/northern-forest-atlas-project-fund

Northern Woodlands magazine
northernwoodlands.org

Torrey Botanical Society
www.torreybotanical.org

ACKNOWLEDGMENTS

Thank you to my amazing agent, Emily Van Beek, for being open to my nebulous "some kind of naturey book" proposal. Emily, I don't know what I'd be drawing without you—something less fun and fulfilling, I'm sure. Thanks to the folks at Quarry: Mary Ann for finding me in Cleveland, and Joy for patiently shaping my nebulous proposal into a very real book!

Thank you to my parents for a childhood of road-tripping around the National Parks. Mom and Dad, thanks for continuing these family outings outside the States and into my adulthood. Many of the most amazing things I've ever seen have been with you, from iced-over Taipingshan to the Te Anau glowworm caves. I hope we can see many more places together!

Thanks to my great friends for all of our (increasingly exciting) hiking trips! I am so happy to share these memories with you. Half Dome, bioluminescent kayaking, scrambling in Shenandoah, Precipice Trail in Acadia—what a year. Also, thanks for stopping me whenever I want to do crazy things.

Lastly, thank you to Michael for giving this book the credibility I was hoping for. I couldn't have asked for a more kind and knowledgeable science writer to collaborate with!

—Julia Kuo

I am thankful for the opportunity to work with Julia Kuo and with Joy Aquilino and everyone else at Quarry Books on a project that combines the science and the art of trees (which to me are one and the same thing). Julia's tremendous desire to delve deeper, to get things right, and her ability to turn concepts into artful expressions made integrating my writing with her terrific words and illustrations a great pleasure.

Numerous mentors have supported my lifelong curiosity about the natural world. Many people at Antioch University New England, including Tom Wessels, Peter Palmiotto, Paul Hertneky, and Fred Taylor, encouraged my multidisciplinary approach to studying and communicating about nature; they have helped me delve into a growing list of curiosities and questions. My parents have always encouraged me to follow my interests in art as well as science, and Samantha Burnell helps me see and appreciate beauty in a deeper way. My daughters Luna and Leo never cease to inspire my sense of wonder and awe as we wander through the woods and through our lives.

It is with great joy that I imagine you, the readers of this book, learning about and drawing trees; I hope that this process deepens your connections with the natural world, especially the places where you live and frequent.

—Michael Wojtech

ABOUT THE AUTHORS

Julia Kuo grew up in Los Angeles and studied illustration and marketing at Washington University in St. Louis, where she has also taught illustration. (Most of this book was completed right by the lovely Forest Park in St. Louis.) Julia currently works out of Chicago for most of the year and Taiwan in the winter. She illustrates children's books as well as editorial pieces for newspapers and magazines. Her clients include ScienceFriday.com, the *New York Times*, Hachette Books, Simon & Schuster, and Macmillan Publishers. Her illustrations have been honored in *American Illustration*, *CMYK* magazine, and *Creative Quarterly*. When she's not drawing, you might find her running around in a national park and looking at moss. See more of her work at www.juliakuo.com.

Naturalist **Michael Wojtech** earned his master's degree in conservation biology from Antioch University New England and is the author of *Bark: A Field Guide to Trees of the Northeast* (UPNE, 2011). A freelance writer, educator, photographer, and illustrator, Michael's work has appeared in *American Forests*, *Northern Woodlands*, and other publications. He teaches about the identifying characteristics, ecology, and beauty of trees at arboretums, schools, nature centers, museums, garden clubs, libraries, and other organizations. Michael strives to share the process of discovery—the keen observation, finding nuance and beauty in infinite layers, and the evocation of multiple senses—and inspire the creative expressions and connections that flow from these experiences. He and his family live in and explore the forests of Western Massachusetts. Learn more about Michael at www.knowyourtrees.com.

INDEX

Italicized page numbers indicate an illustration.

acorns, 6, 16–17, 24, 27–29, 77
aging trees, 106–107
angiosperms, 14, 69
apple trees, 72–73, *78*
ash trees, *6*, 21, *49*, 56, 57, *118*
aspens, 50–51, 103, 109, *118*

baobab trees, 112–115
bark, 40–41, 46–51, 88–89
bats, 101
beech trees, 48–49, 51, 57
birches, 24–25, 48–49, 51, 57
birds, 27, 29, 100–101
black walnut trees, *86–87*
blossoms, 71–73, 133
blue jays, 29
Bodhi trees, 134–135
bonsai trees, 136–139
bristlecone pines, 42, 108–109
buds, leaf, 57, 87
butterflies, 102–105

cacao trees, 124–125
cambium, 40–41, 46–47
catkins, 22, 25, *54*, *66*, 94
cherry trees, 52–53, *78*
chlorophyll, 18, 58
club mosses, 14–15
cones, 14, 22–23, *64*, 68–70, *96*
conifers, 14–15, 22, 25, 68–69,
 92–93, 96–97
cork, 46–47
crabapple blossoms, *72–73*
cypress trees, 92, 96–97, 109

dead trees, 16–17
deer, white-tailed, 28, 30–31
dogwoods, 14–15, 74–75, 88–89
drupes, 52, 54, 77–78
ducks, wood, 29

ecosystem services, 123
elms, *6*, 87–88
embryos, 20–21
epiphytes, 100–101
eucalyptus trees, *24*, *25*, *49*

ferns, 14–15, 100
ficus trees, *34–35*
figs, *78*, 80–81, 134
firs, Douglas, 64–65, 98–99
flowers, 68–69
forests, famous, 110–113, 117
fruit, 77–79

germination, 20–21, 26–27
ginkgos, 14–15, 66–67, *118*
growth rings, 41–45
gymnosperms, 14, 68
gypsy moths, 103

heartwood, 40–41, 44, 47
hesperidiums, 77–78
hickory trees, shagbark, 54–55
hornwort, 14–15
horsetails, 14–15

identification, tree, 86–87

leaves, 56–63, 66–67, 86–89, 118–119
liverwort, 14–15

magnolias, 14–15, *72*
maples, *6*, 25, 48–49, 57, *118*
monarch butterflies, 103–105
mosses, 14–15, 100
moths, 102–105
mycorrhizal fungi, 98–99

needles, 60, 64–65, 92–93

oaks, 14–16, 24, 48–49, 60, 118–119

peaches, 6, 71, *78*
pears, Williams, 78–79
persimmons, *78*, 82–83
photosynthesis, 17, 18–19, 51, 58–59
pines, 14, 22–23, 42, 48, 60, 64–65,
 108–109, 111
pollination, 70–71, 101, 131
pomegranates, *78*
pomes, 77–78

rays, 40–41
redwoods, 109, 111
reforestation, 126–131
resources, tree, 140–141
roots, 17–21, 32–37, 59, 98–99, 109

saplings, 16–17
sapwood, 40–41, 44, 47
seedlings, 16–17, 33, 98–99, 128–129
seeds, 6, 14, 16–17, 20–21, 24–27,
 69–70, 77
sequoias, 42, 51, 109
snags, 16–17
spruces, 14, 48–49, 92–93
squirrels, gray, 27–28
stomata, 58–59
sycamores, *6*, 36, 57

tannins, 51, 125
taproots, 32–33
transpiration, 59–60
trees, 14, 86–87, 90–91, 122–131,
 133–135, 140–141
trunks, 38–46
twigs, 87–88, 131

walnut trees, 6, 77, 86–87
willows, 25, 36, 51, 94–95, 125

yews, 26, 109